☰☷ *Ting:* The Caldron

SAN FRANCISCO: GLIDE URBAN CENTER, 1970

 Ting: *The Caldron*

CHINESE ART AND IDENTITY IN SAN FRANCISCO

Ting *is presented by the Glide Urban Center*
as part of its ministry of reconciliation. Edited by Nick Harvey.
Special Consultants: Development: *Loni Ding, Robert Johnson, L. Ling-chi Wang*
Chinese Art & Literature: *Tseng Ta-yu* Design: *Susan E. Gandy Sotelo.*
Cover design suggested by Keith Lind; calligraphy by Tseng Ta-yu.
Copyright 1970 by Glide Urban Center Publications,
330 Ellis Street, San Francisco 94102.

Realized through financial arrangements made by Mrs. Dorothy L. Martin,
Phyllis Lyon, and Mr. & Mrs. Elbert Hoffman.

Printed by East Wind Printers, San Francisco. Manufactured in the U.S.A.
Library of Congress Catalog Card Number: 76-111228.
ISBN 0-912078-14-6.

Foreword

TING: THE CALDRON, the fiftieth hexagram in the *I Ching* or Book of Change, represents the ancient vessel in which is proffered the cultural, artistic, and spiritual sustenance of a community. The *ting* belongs to all: it is the vehicle for reconciliation, in which young and old, Chinese and non-Chinese, all find their common ground. Every member of the community must contribute to fill the *ting,* for on this cooperation depends all capacity for growth. Everyone must return to the *ting* for self-understanding and interpretation, for in the *ting,* the "Middle Kingdom," is what is common to all. The *ting* holds together for the whole community that which is eternal in its self-encounter.

Our *ting,* too, belongs to the whole community. Its varied contents of art and cultural commentary have a common implicit theme: the encounter between Chinese culture and the U.S., differing for each individual, conditioned always by the unique presence of San Francisco. This theme was not imposed from the outside. *Ting* was, from the very beginning, allowed to take its own course, the only initial editorial guideline being to concentrate on artists and issues lacking sufficient exposure outside the Chinese community. All members of the community, whatever their activities or attitudes, were encouraged to make whatever contribution they felt appropriate, in whatever language they chose. From this freedom, latent with surprises, *Ting* developed its own contents and direction. As it grew, one could see emerging the fragments of an endless story: the search for a Chinese-American identity. In every case the tension between these two opposing cultural expressions has precipitated this intense self-exploration of what it means to be Chinese in the United States. For some this is rediscovered in a responsibility for action and community change; for others it is the ground for art. In both cases it is significant that non-Chinese—in our book, people like Lorna Logan, Kenneth Rexroth, Gary Snyder—too have found a part of their identity in the whole expression of Chinese culture.

Our *ting* is only a beginning. Many artists were not reached in time to be included; very many more remain still undiscovered. Almost all our contributors have showed only the smallest part of their resources here. It is hoped that the *ting* will continue to grow and fill, as all communities and peoples in the U.S. come to realize the depth and significance of the Chinese-American experience.

N. H.

Contents

Art

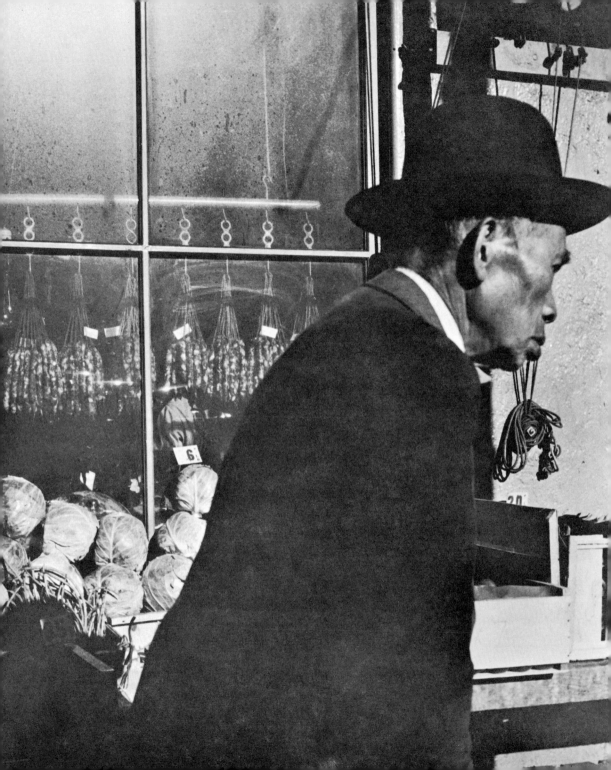

Lorna Logan

INTRODUCTION: CHINATOWN

Photograph by KEM LEE

MINE is a view of Chinatown from the old red brick building on the hill that is now called Donaldina Cameron House. The clinker bricks came through the fire that followed the earthquake in 1906, but the work that goes on there had its beginning at just about this location in the roistering days of 1874. From this vantage point have been seen great changes coming to the community and yet many things that remain the same.

The location of Chinatown remains the same. San Francisco grew up around a plaza, what is now Portsmouth Square. As the town grew and its center drifted away to areas south and west, the Chinese moved in and have been here ever since, in spite of repeated efforts on the part of the Caucasian community to relocate them. Persecutions, riots, lynchings took place; but the people persevered. After the earthquake and fire, there was a particularly serious effort to establish Chinatown in another location; but it was unsuccessful and Chinatown remained, providing the city its most colorful quarter and its greatest tourist attraction. Its charm and beauty serve to hide much of the poverty, the squalid housing conditions, the deprivation that exist there.

Will Irwin wrote nostalgically of Chinatown as it was before the fire: "Its inhabitants, overflowing into the American quarters, made bright and quaint the city streets. Its exemplars of art in common things, always before the unillumined American, worked to make San Francisco the city of artists that she was. For him who came but to look and to enjoy, this was the real heart of San Francisco. This bit of the mystic, suggestive East, so modified by the West, that it was

neither Oriental, nor yet Occidental but just Chinatown.''*

The fire and earthquake did away with the old Chinatown that was immortalized in the pictures of Arnold Genthe and a new Chinatown arose. It is hard to think of Chinatown as having once been new and bright and fresh, but it grew up without much planning to meet the needs of a population that was largely made up of single men who had come to this country to seek work and opportunity and which made little provision for a community of real homes. When I arrived at the relatively recent date of 1932, Chinatown was still largely restricted to an area of about three blocks in one direction, four in the other. Around this, there was an invisible wall and Chinese were not permitted to live outside except at a cost of harassment and sometimes persecution. The smell of drying salt fish, incense and indefinable spices mingled to give Chinatown a characteristic smell, and not only interest but beauty seemed to be available in the shops and in the work of the goldsmiths and other craftsmen along the street.

I came to join Donaldina Cameron and her staff at the building that now bears her name at 920 Sacramento Street, then called the Presbyterian Mission Home. Miss Cameron, that amazing gentlewoman fighter for the oppressed, was nearing the end of her forty years' battle against the slave traffic. She had provided both refuge and mothering for a host of young women and girls from China through these years, and had had

*Old Chinatown by Arnold Genthe & Will Irwin, p. 1f.

10

much to do with bringing to an end this one-time profitable trade in human lives.

But the community was changing and more and more becoming a place of families and homes, and the people who came to Miss Cameron were coming not alone out of concern for some mistreated girl. They came because they needed an advocate with the immigration authorities or a guide about family discipline or an intermediary in some family dispute. To many in all walks of life, she became known as *Lo Mo,* "mother," and as the slave traffic dwindled away, more and more of her concern and eventually mine and that of the other staff became the human problems of a newly arrived population.

Gradually breaks were made in the invisible wall and the Chinese began to spill over into the surrounding area, but population remained dense. We greeted with great enthusiasm the opening of the first Ping Yuen Housing Project and it did provide the best housing that was available in the community; yet even the additional Ping Yuen buildings are totally inadequate for the needs of today, and crowding seems as bad as ever—except that the prices of housing have gone up!

Chinatown today fulfills many functions. For the immigrant, it is a reception center, a first home where he can begin adjustment to his life in a new country among people of his own background and language, surrounded by the familiar foods and smells and sounds of home. For him, too, it is the place where opportunities are centered: the jobs, poor-paying and hard though they are, that alone are available for the non-English speaking or unskilled applicants, along with the services of English language classes, Chinese-

speaking doctors, social workers, and Chinese businessmen.

To the older resident living anywhere in the Bay Area, Chinatown is the center of social, cultural and business life to which they return—some daily, some just on weekends—to do the family marketing for Chinese foods, see relatives and friends, and perhaps attend a wedding banquet. More and more of these who have moved away from Chinatown, especially the American-born, are today taking a hard look at the community and its severe problems and looking for ways in which they can give leadership to changing the conditions of deprivation and hardship that exist there for so many.

For the city, Chinatown is a tourist attraction still with its delightful restaurants and its colorful shops. Yet the financial and business section moves further and further up the hill, encroaching upon what was part of Chinatown and reducing its area for business, increasing the crowding of its housing. The core area of Chinatown now has the highest density of population of any area in the United States outside Manhattan and there seems no place to expand.

So Chinatown changes and yet remains itself. Perhaps the most significant change is happening in the people. The early immigrant suffered in many ways, but he came with what seemed a rather serene confidence that he came from the greatest history and culture in the world. While he made such adaptations as were necessary and expedient, he never doubted that the old ways were best. But the old patterns, the old ways, no longer work in this modern Western society, and

his children have been faced with the temptation of giving up all that was old and plunging into an attempt to become Caucasian-Americans. Today, however, many first, second and third generation Chinese-Americans, like the youngsters who race over the old building here and who stream out from it to daycamps or other activities, are seeking and finding their true identity. Regaining knowledge of and pride in their roots—the Chinese cultural heritage—and the achievements of their own parents and grandparents who made the great leap into this foreign society and have both adapted to it and adapted it to their own values, they are finding their unique role as those who can contribute to the total life of the society as no one else can do.

For many this process is painful, compounded by discrimination, poverty, poor educational opportunity, alienation from both Chinese and American society. But in their struggle, they are making evident these problems that have long been concealed from the general community, and may speed the day when Chinatown will not only be a place of interest for the tourist but a place of opportunity and fulfillment for all its people.

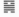

I

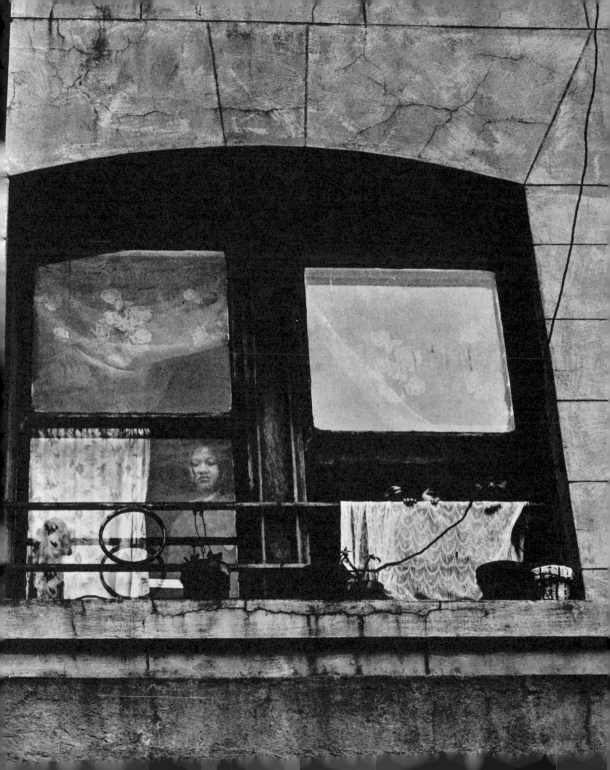

Victor Wong

CHILDHOOD 1930'S

Photographs by IRENE POON

GARMENT factory in Chinatown. There may
be no economic justification. Labor unions see
the system as substandard.

But I'm speaking only of its social significance.
I grew up in a garment factory. I am speaking
only of the time my mother worked in a factory
when I was a baby and a small boy. In the early
30's.

My mother tied me to her back and sewed.
Sister was in early grade school. Father away and
working. The constant drum of sewing machines.
The chatter of Cantonese. The F car rolling and
rumbling from somewhere through Stockton
Street near the tunnel. Stop; screeching and ding-
ding off again to somewhere not Chinatown. The
cable car straining up hill.

When the sewing machine stopped I would
wake and cry. Waaaaaaa.

Soon I was too heavy and crawled about
among scraps on the linoleum floor shooed here
and there in the confines of a long narrow cor-
ridor between sewing machine pedals and wheels
and sides of the bins of material and clothes.

There was no variation in routine. The com-
fort of sameness.

Were there other children? I remember none.
When I was walking I played with the owner's
boy. He had a harmonica and a Chinese drum.
I had nothing it seemed. Then on sunny days I
would play outside on the sidewalk by the corner
where the cable car came uphill and the street
car rumbled to and fro.

No balls or throwing objects. There are always
the hill streets of Chinatown down which so many
toys were lost forever. Goodbye red ball.

Once, only once the gentle wind blew by a
thistle. I chased after it. It slipped by my fingers
and sailed on to the pavement. The thistle came
to rest in a crack and from the white hairs out
crawled a black bug and quickly legged away.
What a miracle!

Mid-mornings a man in a dark suit would come into the factory. Almost all sewing would stop. He would pass papers around. Chinese characters on it with holes. "For good luck, for good luck," someone shouted and mother would hoist me on her lap. My fingers grabbed a pencil. I would indicate this Chinese character and over there another. Ten times and each time my mother would steady my fingers to circle ten characters.

This was lottery time. For a nickel or a dime or more each lady would record the ten choices.

Lottery man with pencils in every pocket and a tablet of paper would record the ten choices.

Off he would go. And the sewing began again. The social gossip and laughter blended in. I began again to play. And I thought simply, "Who will win today in the lottery?"

For whoever wins enough, that lady may buy lunch and I may eat good food. Most meals I ate only a bowl of rice, a cube of butter in it with a blot of soy sauce.

Everyone waited and worked and I played. The cable car dinged and the F car rumbled, rattled by.

Late morning the man's shadow covered the door outside. He twirled the ball and entered with note book and lottery in hand. All machines stopped.

So and so words were picked by the lottery company today. "Ahhh," sighed Sarah's mother, "I am lucky today."

"Me too," said Mrs. Wong near the back. "Who buys lunch?" someone asked.

"Ah, I guess I will today," said Mrs. Lee, the owner's wife. And everyone laughed. "Only Mrs. Lee has enough money to bet to win large money," someone said. "Anyway, good food is good for everyone," said Mrs. Lee, the owner's wife, and went to make a phone call.

"Hello, give me Toa Yuen restaurant," she said, in Cantonese of course. Those days Bell Telephone had a Chinatown station of all Cantonese operators. Numbers of Chinatown phones were seldom given to the operators. "Give me Fat Ming Stationery Store" or "give me the home of Ah Sam the rataan chair mender," and the operator knew by heart.

"Hello, this is Mrs. Lee at the garment factory. Give me five dollars of *dim sum* for noontime. Hurry." *Dim sum* means lunch of assorted meat buns and meat wrapped in wonton skin, with egg rolls and sponge cake and rice jello. And good? Very delicious. Universally delicious. Socially delicious. Life was worth living with *dim sum*.

Streets away the lunch was loaded onto a wooden tray and covered with hot muslin. A street waiter would porter the heavy tray atop his head and waddle through the hilly streets to customers. Everyone stepped aside for him. He was a neighbor earning hard money to make people happy.

"Waay, the food's here," he shouted at the door.

"Get out of the doorway," my mother shouted at me. Someone opened the door and in would sweep the waiter. Adeptly he lowered the tray on a table and lifted off the muslin. Oh, the aroma! "Boil some tea," shouted the owner to Mrs. Lee, "lots of tea. Eat, eat, everyone eat!" Mother raised me to her lap and I ate, too.

* * *

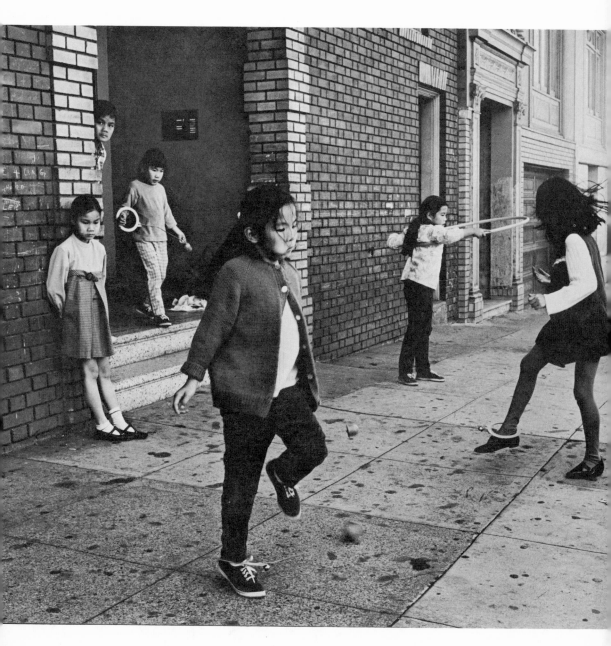

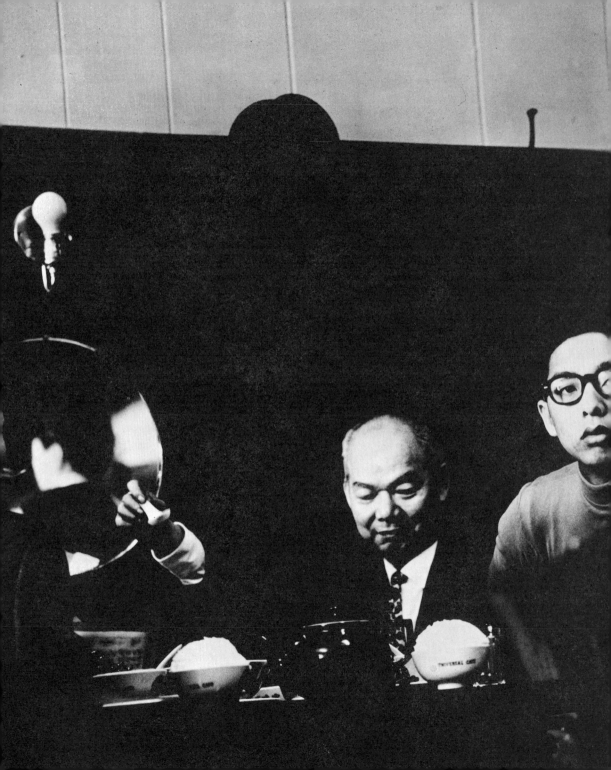

THOSE days there seemed to be a wedding every weekend. You could tell because one of the things that always went on with a Chinese wedding banquet was the Chinese music. In those days they didn't have any recording machines, any phonograph players, so the music was live; and it was very, very noisy; people gathered so that around 6 o'clock every Saturday and Sunday you could see great throngs of people, and you could tell from the way they dressed that this was a wedding. Because usually people didn't dress up at all. As a matter of fact, until the 1950's the men all dressed down. If they had money they wouldn't show it at all. You lived in a very tight community, and everybody knew each other; if you had money, you know, somebody—one of the relatives, in that complicated system of uncles and aunts and so forth—*somebody* would ask for a loan. So you tried to never mention how much you had, never. People generally dressed pretty much alike. The only time that you would see a difference was when there was a wedding banquet, which in the 30's were fantastically lavish events. The bride and the groom would wear things that were even more extravagant than what we see now on the stage in Chinese opera: lots of jewelry, and clothes that had been made in China and were richly, richly decorated, all handmade. . . . Some of them were blindstich; as a matter of fact, in those days during weddings they were all largely blindstitch, I think. The blindstitch was so detailed that the person who made the garment would very often go blind very early in life, just because of the closeness of the work.

I don't remember what the bridegroom wore. I seem to remember that he too wore a very elaborate gown, a man's gown, dark silk, like a man's Chinese tuxedo; and of course always the hat which would kind of resemble a yamalka, except that it was black and had a kind of red tassel on the top of it. That was quite common then.

I could never figure out how they managed. They'd have fifty to one hundred tables and each table would hold ten persons, so maybe there'd be five hundred to a thousand persons at one wedding banquet. There would be ten or more courses of food, too, very specially made. . . . And they would drink—I mean, when there's a wedding, the men would drink really a *lot* of Chinese whiskey. Chinese whiskey was different from, say, Western spirits in that it had an odor to it that just went clear to your head. It was like smelling mustard, you know—really powerful stuff. It goes down hot and the fume of it just goes right on up to your head and waters your eyes.

But those were the only times as a child that I remember ever seeing anybody get drunk. I never saw a man get drunk on the street. I remember my father coming home drunk one night just once in my whole lifetime. And when a person gets drunk at a party he's always taken home by a relative or friend; he never walks home alone.

But aside from these banquets, the other thing that we would consider high ceremony today would be the death of a person. That, too, seemed to happen every weekend. There would always be a funeral march during the day to the cemetery. They would have a band, a brass band, what we would call municipal bands in the city; all the guys wore dark suits with brass buttons

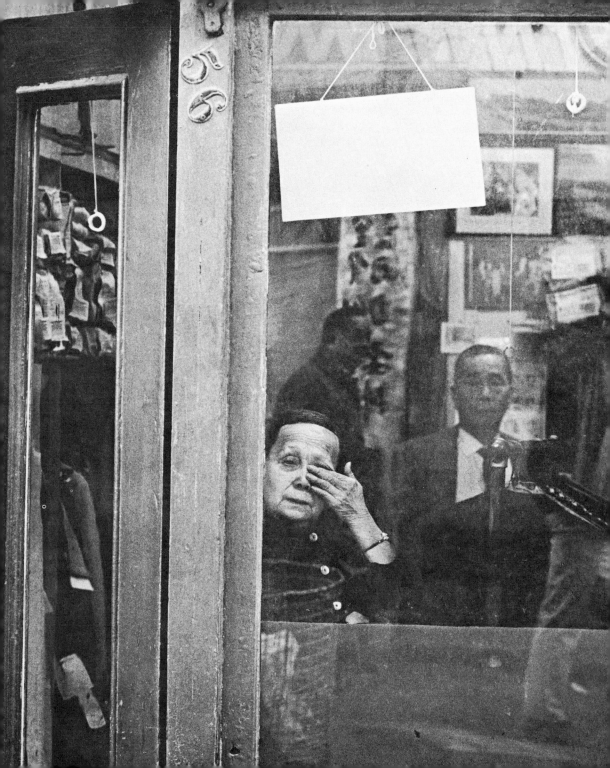

and white caps, I remember, like the captain of a ship, and they all wore white gloves, always. They played the trombone, the tuba, a big bass drum; and they would always play some Western music, like the funeral marches of Wagner or whoever wrote those things. That was my first introduction to European music. And they were always followed by an open Lincoln, an enormous touring car, probably twelve cylinders, with all the chrome and the brass and gold and everything all shined up, and on top of the windshield there would be a photograph of the deceased person that was something like forty by sixty inches—I mean, an *enormous* photograph of the person who had died, all ringed by flowers. I don't know how they had it ready, but it was always there. That's how you found out who had died. I've forgotten who sits in the back seat—for instance, if it was a wife who had died, I think the husband would be sitting in the back seat, and so forth—but then following that there would be the immediate family: the children, the grandparents, everybody dressed in black or wearing a veil. And they would have professional mourners who would cry—terrible wails—and then all the friends and relatives would trail behind, *walking,* you know, right through Grant Avenue. They went to the house in which the person had lived, and then they would turn and come back to Grant Avenue and those who could would walk right through the city to the cemetery, which was way at the end of town— down near Daly City. A good ten mile, five mile walk. . . . In those days, you know, the burial and so forth would be done by the Chinese them- selves; they didn't have any professional services. Ahead of time somebody would arrange for a plot of ground for the burial, but I imagine in those days often the grave wasn't even dug until the guys got there. So they would dig the thing and then come back. . . . They had a hard time

finding grounds, and I think what finally hap- pened in my family is that there was a big plot of ground that was sold to us by the Russian Orthodox Church. It was a weird place, because it was way at the edge of town and always ringed by those Monterey cypress—gloomy looking trees, you know, all gnarled. It was very fore- boding.

But can you imagine, here's a band, a brass band, playing some classical music that would fit the situation, just like with the death of John F. Kennedy: the slow roll of the drums, and—what's a funeral march?—something Wagnerian; like *Tristan and Isolde,* something like that. That would be the first thing you would hear, this kind of music. And then would come the touring car, and the wail of women crying. . . . And then, too, was when the status of a person came across, how wealthy he was. Because the wealthy person would have a *large* band, and then a touring car with his picture, and then *thousands* of people, so that it would take a half hour, a *whole* hour to get through Grant Avenue. For instance, I remember one time when somebody said that a gambling king had a funeral and it took some- thing like two or three hours. And I think that four or five bands played—just a fantastic thing.

But Chinese New Year, of course, was our big- gest celebration. Chinese New Year was the time in which we blew firecrackers *day* and *night;* it was—just day and night, firecrackers. We used to have firecracker fights, we got to know firecrack- ers so well. This was for older kids, kids who were teenagers; the gangs would have *wars* with firecrackers, tossing them at each other. They protected themselves by wearing heavy clothes and wrapping things around their heads, and they'd just *toss* at each other all down Grant Ave- nue. But you never heard of anybody getting hurt. I remember someone once had a firecracker blown inside of his pants—lit it by mistake—but

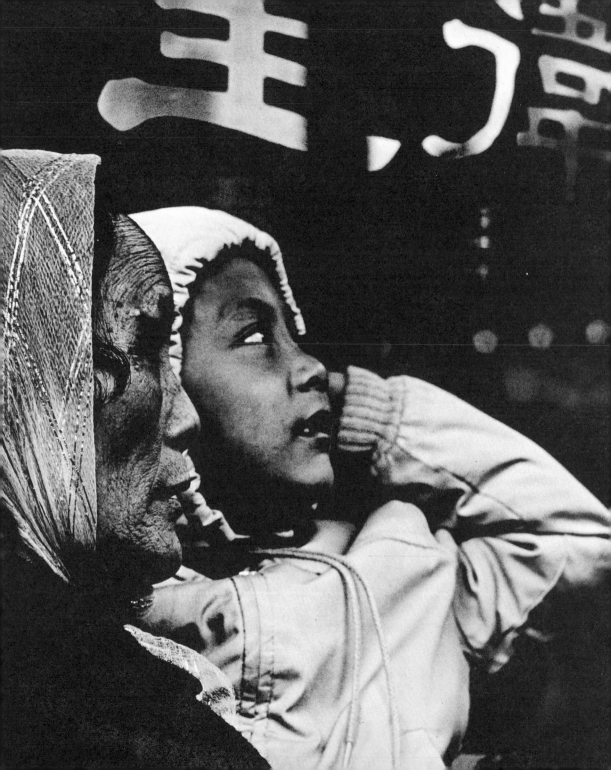

he had a black and blue mark and that was about it. You got to know that as soon as you see one coming close to you, you cover your face. And the kind of firecrackers we used to have really didn't do that much damage, even though they were the kind with the gunpowder, which today is outlawed. But in those days they came from China; they were really gunpowder, black powder, and they smoked a lot. So throughout the whole Chinese New Year, which lasted *ten days,* the air was always just filled with smoke. And by the time of the second day of the New Year, there would be so many firecrackers blown that the town was just literally covered with red paper. It was a *hell* of a time for the English school teachers.

But these holidays—of course, we would have the American ones too, Thanksgiving, Easter, Christmas, and American New Year, and the Fourth of July—but somehow they were always turned into kind of Chinese celebrations. For instance, in the churches the songs would be American tunes—or, that is, European Christian tunes—but they would always be sung *in Chinese* Thanksgiving, Christmas, and Easter. And American New Year, January the First. On American New Year we never went anywhere, adults or children, but walked from California Street down Grant Avenue to Pacific and back on the other side of the street, back and forth, back and forth. There were no cars parked in those days because people had no cars. And there were no tourists, there were just all Chinese there, and we would just go around and around throwing paper at each other, you know, these confettis, which some kids and men would sell. They would go out somewhere and buy a *huge,* fifty-pound sack of confetti which was—my God, as a child I remember it was higher than I was—and they would sell them in little paper bags, for a dime and a nickel, and this was really high celebration.

But by midnight you sloshed through about a *foot* of confetti. Just a foot of it! And it's a funny thing, but people were so well-mannered despite everything that they never picked it off the street and threw it at each other again. Not even the kids; it was a strange thing. That was one thing that we *frowned* upon, you know—that is, the kids themselves imposed this on each other. Once it's on the ground, it's on the ground. So by the time eleven or twelve o'clock came around the street was just *loaded,* and you slushed through a foot of the stuff. It was amazing. . . . We had a *hell* of a good time, holidays like that.

The Fourth of July, too, was a great time because of the firecrackers. But the Fourth of July was especially the time when the *whole town went to a picnic.* And in those days we didn't have any money so we made special arrangements to board the local trolleys and streetcars and go out to Golden Gate Park. And they were—my God, *everybody* went out on them. *Everybody went out.* I remember, the most memorable was what seemed like on a windy day on a field out at Golden Gate Park they would fly a dragon kite that was something like a *half a block long.* And I remember the rope that they towed—I don't know who made it; I think it was sent from China—about an inch in diameter; it was like the kind you moored a *ship* onto. And there was a whole block of men that grabbed hold of the rope while other people held the kite, and at a signal they would start running with it, on this *long,* long field out in Golden Gate Park, and the thing would start to go up. And they had things that they built into the kite which made sounds, so it was just a *frightening* spectacle to see the whole thing just *roaring* and then taking off into the air. . . .

But I mean, it was as if the whole Golden Gate Park was taken over by Chinese. I remember seeing people who would come over to the gate

there and see all these Chinese, with that kind of
startled look on their faces, and then just turn
and go away. "Let's leave these people *alone,*"
you know. Because in those days people were
afraid of Chinese, because of funny stories I guess
they heard about gambling and prostitutes and
how people would be kidnapped and white wo-
men made into prostitutes and all that kind of
stuff. I don't know, it didn't seem that violent
to me. I felt it was safer in those days, it was a
richer life, than it is today. . . .

But Fourth of July was never thought about
much except that it was a day to go to the picnic.
As a national holiday it didn't mean anything to
us at all. In those days, to begin with, the Chinese
couldn't even vote; so the only political party we
had was the Chinese Nationalist Party, the Kuo-
mintang. And China and Japan were at war
then, so the Kuomintang was always trying to
drum up business, trying to raise money to send
to China. So every opportunity there was, there
would be a political parade. Which meant that
every school, whether it was Catholic, Protestant,
or the Confucian school we had then, or the
school that was run by the Chinese Six Com-
panies, in every school we would *all go out and
march.* Little kids would dress in suit pants and
a white shirt, always, and carry the flag or some
sign, demonstrating—trying, you know, to rouse
the spirit of patriotism toward China.

But it was always China that we were taught
was home. In those days, we were all *immigrants.*
Whether we were born in America or not, we
were all immigrants. . . . ☰

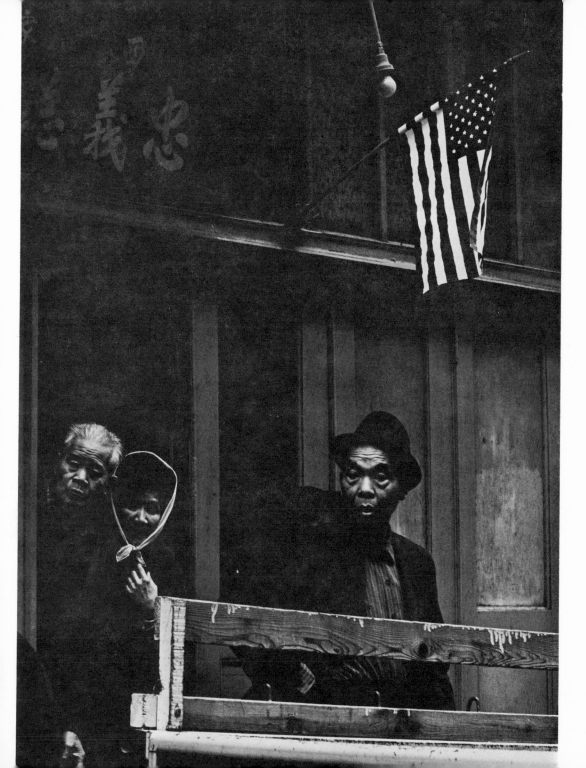

NIGHT IN THE HOUSE BY THE RIVER

It is late in the year;
Yin and Yang struggle
In the brief sunlight.
On the desert mountains
Frost and snow
Gleam in the freezing night.
Past midnight,
Drums and bugles ring out,
Violent, cutting the heart.
Over the Triple Gorge the Milky Way
Pulsates between the stars.
The bitter cries of thousands of households
Can be heard above the noise of battle.
Everywhere the workers sing wild songs.
The great heroes and generals of old time
Are yellow dust forever now.
Such are the affairs of men.
Poetry and letters
Persist in silence and solitude.

TU FU

translated by
Kenneth Rexroth

RUBY LEE: *Landscape*

閣夜　杜甫

歲暮陰陽催短景
天涯霜雪霽寒宵
五更鼓角聲悲壯
三峽星河影動搖
野哭千家聞戰伐
夷歌幾處起漁樵
臥龍躍馬終黃土
人事音書漫寂寥

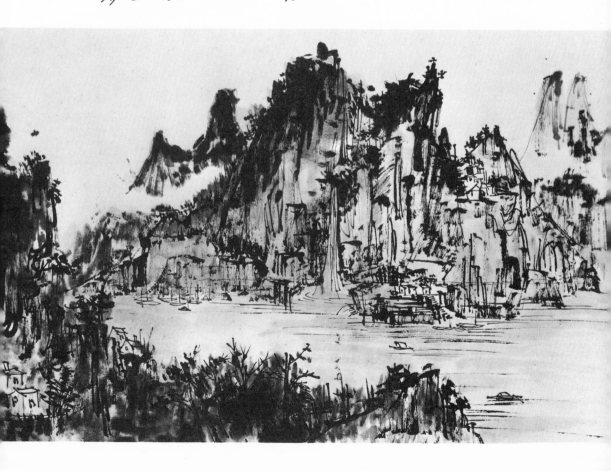

Calligraphy is the source and purest expression of the principles and even the strokes of Chinese painting. This illustration is by Chi Pai-shih (1865-1957).

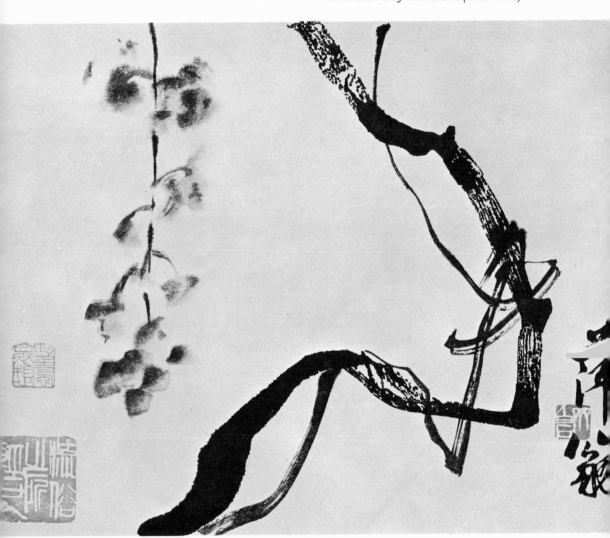

CALLIGRAPHY

FOR *as long as we have records, calligraphy has been an integral part of Chinese daily life and all its arts. The traditional love and respect accorded to the written word persists even today, despite the proliferation of "dead" printed characters: a good piece of calligraphy, no matter what its message, is valued in a Chinese home even more than a painting would be, out of an almost religious respect for the mystery that so much life and power can be caught by the human hand.*

Even in their earliest form these characters were drawn not so much to picture natural objects as to capture in abstract lines the quality of life, strength, harmony, and movement they possessed. Every great calligrapher since has drawn inspiration from close concentration on the beauty of favorite natural objects, from which all written strokes derive their life. The dynamic, asymmetric equilibrium of a well-written character can be better understood if it is thought of as a living form in motion, a skilled dancer or athlete, possessing head and limbs, direction and center of gravity.

Chinese calligraphy, particularly in the *hsing-shu* or running style, is abstract art with recognizable symbols. It should be powerful like a warrior, and yet refined like a poet. It should be steadfast like a mountain, and yet flowing like a running stream or floating clouds. It should have both muscles and bones. It should reveal the true character and sensitivity of the calligrapher. A piece of calligraphy should be rhythmic like music, picturesque like a landscape, and graceful like a dance.

> *Tseng Ta-Yu*
> "Chinese Calligraphy as Art"

多文為富

無訧則訧

羣山萬壑赴荊門生長明妃尚有村一去紫臺
連朔漠獨留青塚向黃昏畫圖省識春風
向環珮空歸月下魂千載琵琶作胡語分
明怨恨曲中論　杜甫詠懷明妃詩　鍾自若

Opposite:
WILLIAM T. R. CHUNG: *A poem of Tu Fu, done in the* k'ai-shu *or "regular" style which evolved from the* li-shu *(p. 30) and a simplified, swifter style of execution called* chang-ts'ao. *The great regularity and beauty of* k'ai-shu *have established it as the most familiar calligraphic style for everyday use.*

Right:
KAI-YU HSU: *The first stanza of Wen I-to's famous poem* Dead Water, *which appears in full in Chinese and English on pp. 60-61. The style is again* hsing-shu, *a rapid, graceful, freer style which developed parallel to* k'ai-shu *and became its close companion. Elements of a character which are separated in more "formal" styles will often be joined in* hsing-shu, *in which even a very complex character may be written with one flowing movement of the arm and hand.*

這是一溝絕望的死水清風吹不起
半點漪淪不如多扔些破銅爛
鐵爽性潑你的賸菜殘羹

一九六零重慶書聞一多死水一章於舊金山

米元章謂書可臨于摹畫
可臨不可摹蓋臨得勢摹
得形畫但得形則淪於近畫
其道盡失矣　丁未夏朱震

詩六首・曾大猷

一

題畫

雲動山猶立
雨收水更流
心同天地合
意自毋貿千秋

Tseng Ta-yu

POEMS AND CALLIGRAPHY

Translations by the author

The clouds may swiftly change,
 but the mountain stands aloft.
The rain may now be still,
 but the water forever flows.
As your heart responds
 in harmony with nature,
Your expressed thought
 will go forth to eternity.

題友人「雲山浩蕩」圖
二

凌霄絕壁驚天地
萬里行雲氣自雄
去國名山無覓處
何來五嶽一望中

2

The cliffs that leap to the sky
 startle heaven and earth,
And the clouds that stretch to infinity
 have such an heroic mien!
Since I said good-bye to my motherland,
 nowhere can her landscapes be found.
But whence come these five Sacred Mountains
 that I see at a glance?

凌霄跨鳳翥

鬱勃乎天地半里

り雲氣句

雄去名山

芳覓夏日

來五嶽一坐

中

曾六獻

YOSEMITE

The rocks that soar to heavens are ever
 spectacular in the lapse of time.
The hanging fountains that plunge to earth
 ever roar like dragons.
Yet our great mountain heeds not
 the rise and fall of human destiny.
How far off she enters into the clouds and mists!

遊美西幽森密地

三

石壁沖天壯古今
懸泉瀉地作龍吟
名山不管人間事
遠入雲霞幾許深

石屋冲天壮

古今显象湾

地作龙吟名

山不爱人空

了远为雲霞

几许深

曾大興

PAUL PEI-JEN HAU: *"Mountain monastery by a stream"*

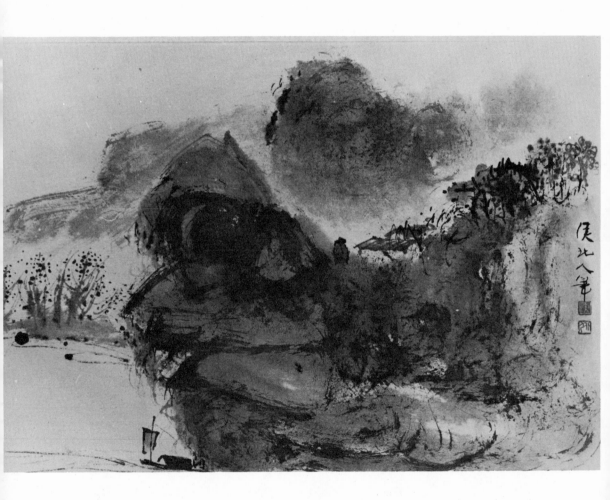

4

All my loves and hates have long
 turned to ashes.
How could forgotten happenings come into
 my dreams?
Tonight the wind and rain are rampant in
 this far off land.
O, do not attempt to fathom my feelings
 at this hour!

5

A little sheet of paper can hold
 heaven and earth.
A little brush retrieves the
 soul of our motherland.
Ah! boundless is your thought
 of the ancient days.
To whom can you relate such depth
 of feeling?

6

For many a mile towers beyond towers
 stand before my eyes,
And the bay, walled by hills
 after hills, has such a gallant air!
The sound of birds turns all trees
 green with tender leaves,
And the springtime rain reddens
 a myriad flowers!

四　無題

人生恩怨早成灰
往事無端入夢來
海角今宵風雨急
此時情緒不堪猜

五　題畫

一紙容天地
筆招故國魂
蒼茫萬古意
深淺共誰論

六　題畫

樓臺十里入望中
山繞金灣氣勢雄
百鳥爭鳴千樹綠
一朝春雨萬花紅

41

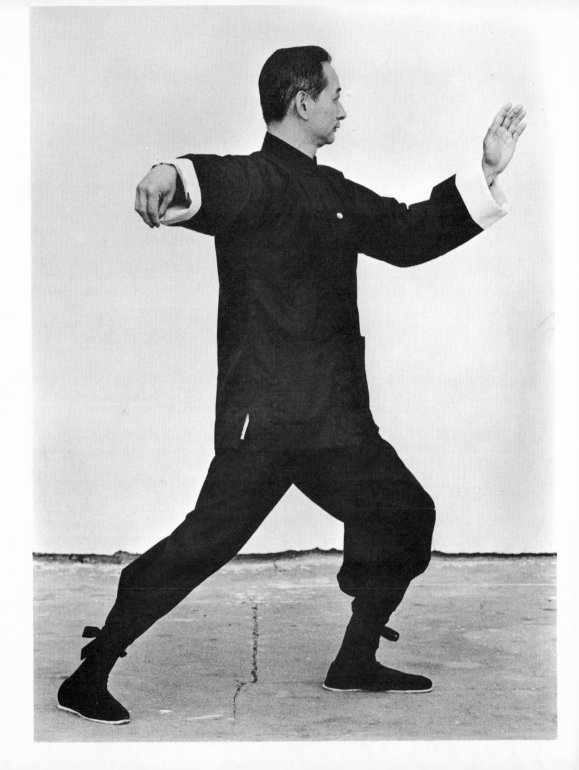

TAI CHI CHUAN

from interviews with Master Choy Kam-man
by Susan E. Gandy Sotelo & Buck Quayle

OVER a thousand years ago in China, during the T'ang Dynasty, Taoist monks were aware of the need for exercise following long periods of sitting meditation. To fill this need they developed Tai Chi Chuan.

Chi is vital energy, the force behind the constitution of all things. It originates below the navel, when the body is at its healthiest state. Tension and anxiety move the locus of this power upward to the chest, when the pulse begins to quicken and the limbs to stiffen, bringing on old age. At death, the *chi* will be found as high as the throat.

Tai Chi Chuan utilizes the close connection between body and mind to reverse this downward process and revitalize the *chi*. When the mind is disturbed, our vital energies are divided against themselves; the body is unable to function properly, and grows more and more susceptible to sickness, age, agitation, and finally death. But the healthy mind, in forgetting the body, does not interfere with its natural processes. Thus body and mind are left free to function as one.

Tai Chi consists of 108 forms or body positions, performed in a slow, controlled, continuous dance-like sequence. To complete one full sequence takes twenty minutes or so, but a master may stretch this out to half an hour. Slowness and concentration are essential. The various forms of Tai Chi are highly complex movements in which all the parts of the body, from foot to fingertip, are kept in close coordination from start to finish. The beginner finds his mind so constantly preoccupied with distracting thoughts and fears that such coordination is impossible. To regain control over the parts of our body we have abandoned to reflex and habit requires that

43

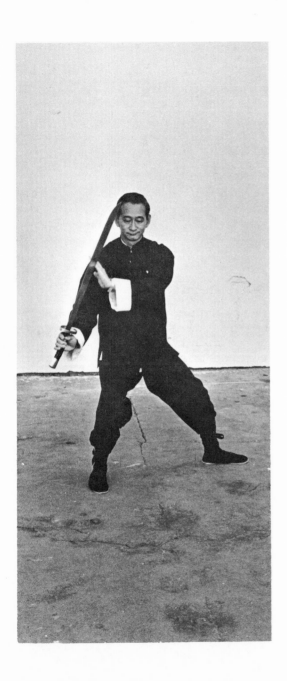

both body and mind slow down. Meher Baba says:

A mind that is fast is sick.
A mind that is slow is sound.
A mind that is still is divine.

Brought eventually to such one-pointed concentration as Tai Chi requires, the mind relaxes, and the distractions of anxiety, fear, and so on fall away, releasing all the tremendous energies locked up against themselves inside.

Tai Chi is considered a "soft" form of Kung Fu, the general class of ancient Chinese martial arts, and most of its movements are much sloweddown versions of these same forms for attack and defense. Many of these forms are reminiscent of Karate; but in Kung Fu the movements are smoother, more flowing: the body in Kung Fu is always relaxed, and solidity of the muscles is achieved through revitalization of the *chi* rather than by building up calluses. Even at the extreme point of a stroke, the body is not fixed in one position; it remains fluid in all its parts, and even while the foremost hand is striking, the rear foot will have begun its retreat.

Tai Chi shares these characteristics and others which betray its ancestry. Students of Master Choy begin by learning the "short form," a simplified method of 54 movements developed by Master Choy himself, and practiced in an approximately ten-minute routine. Following this one learns the "long form," utilizing the full 108 movements. (Altogether, counting the variations, there are some thousand forms in Tai Chi Chuan.) Next is the "joined hands" stage, practiced by two persons. One then progresses to practice with sabre and, finally, the sword, all manipulated in great slow motion with extreme control.

Yet despite its martial antecedents, Tai Chi is not another martial art. Its roots go much deeper, in the Taoist and Buddhist philosophies which gave it birth. In it one seeks and learns to follow the

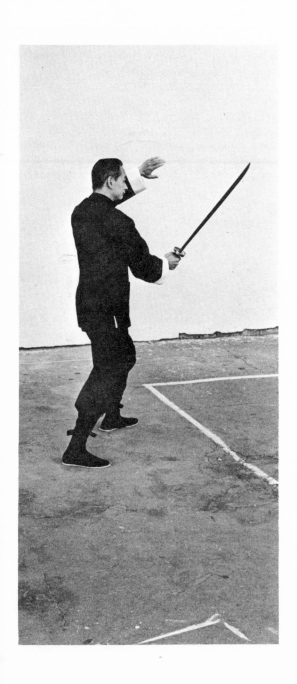

harmony which unites all things. It is, in Master Choy's words, "philosophy in action."

So Tai Chi has an urgent reminder for our times. Anxiety in the midst of rapid change has bred increasing violence between individuals and communities, while on a larger scale we still talk seriously about living with continuous global warfare, utterly devoid of any remnant of humanity. In our fear and mistrust we have come to make personal isolation a way of life, and wonder at the despair and antagonism we find ourselves giving vent to in our daily lives. Long ago the Buddha, an unsurpassed master of practical psychology, stated simply:

All that we are is the result of what we think. How then can a man escape being filled with hatred, if his mind is constantly repeating: He misused me, he hit me, he defeated me, he robbed me?

Hatred can never put an end to hatred; hate is conquered only by love.

In loving and hating, the energy is the same. We can waste our lives and resources on separating ourselves from others and from our environment, our community from other communities, or we can pour these resources into the immense task of seeking instead what unites us, binding together, in our daily life, all that has become fragmented and opposed. Most of us are too "uptight," too fearful of ourselves and others, to find inside the strength to resist when all around us are swept up in the cycle of greed, mistrust, and violence. Tai Chi Chuan, among other related disciplines, offers us all the way back to our common human ground. Through its practice we can learn to draw increasingly on the infinite resources of creativity, love, and direct, non-violent action without which we can never hope to live peacefully with each other or our environment. ☰

46

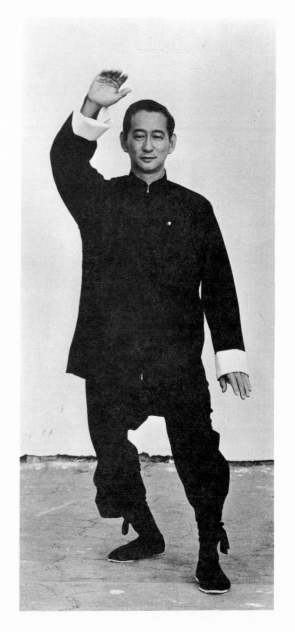

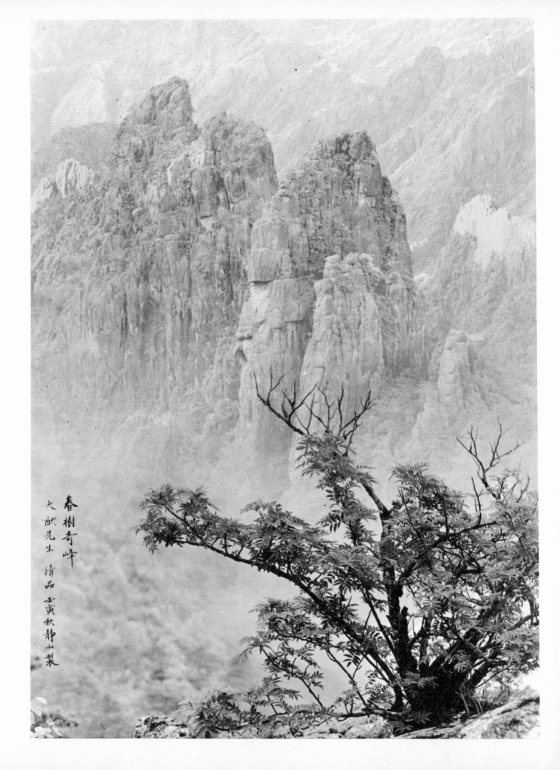

春樹奇峰

大猷先生 清品 壬寅秋靜山製

寒山詩選

一

人間寒山道　寒山路不通
夏天冰未釋　日出霧朦朧
似我何由屆　與君心不同
君心若似我　還得到其中

Gary Snyder

COLD MOUNTAIN POEMS

1

Men ask the way to Cold Mountain
Cold Mountain: there's no through trail.
In summer, ice doesn't melt
The rising sun blurs in swirling fog.
How did I make it?
My heart's not the same as yours.
If your heart was like mine
You'd get it and be right here.

CHIN-SAN LONG: *Mountains in China*

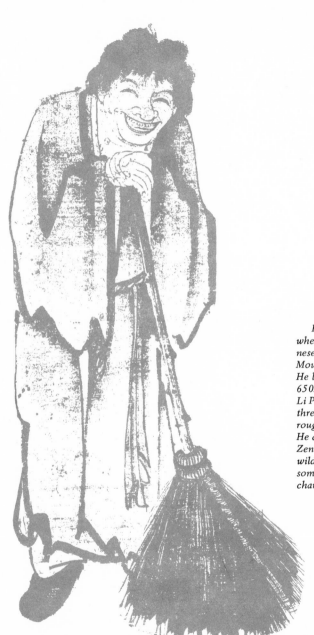

Han Shan, "Cold Mountain," takes his name from where he lived. He is a mountain madman in an old Chinese line of ragged hermits. When he talks about Cold Mountain he means himself, his home, his state of mind. He lived in the Tang Dynasty—traditionally A.D. 627-650. This makes him roughly contemporary with Tu Fu, Li Po, Wang Wei, and Po Chü-i. His poems, of which three hundred survive, are written in T'ang colloquial: rough and fresh. The ideas are Taoist, Buddhist, Zen. He and his sidekick Shih-te became great favorites with Zen painters of later days—the scroll, the broom, the wild hair and laughter. They became Immortals and you sometimes run into them today in the skidrows, orchards, hobo jungles, and logging camps of America. G.S.

50

出生三十年　常遊千萬里
行江青草合　入塞紅塵起
鍊藥空求仙　讀書兼詠史
今日歸寒山　枕流兼洗耳

二

2

In my first thirty years of life
I roamed hundreds and thousands of miles.
Walked by rivers through deep green grass
Entered cities of boiling red dust.
Tried drugs, but couldn't make Immortal;
Read books and wrote poems on history.
Today I'm back at Cold Mountain:
I'll sleep by the creek and purify my ears.

3

On top of Cold Mountain the lone round moon
Lights the whole clear cloudless sky.
Honor this priceless natural treasure
Concealed in five shadows, sunk deep in the flesh.

三
寒山頂上月輪孤
照見晴空一物無
可貴天然無價寶
埋在五陰溺身軀

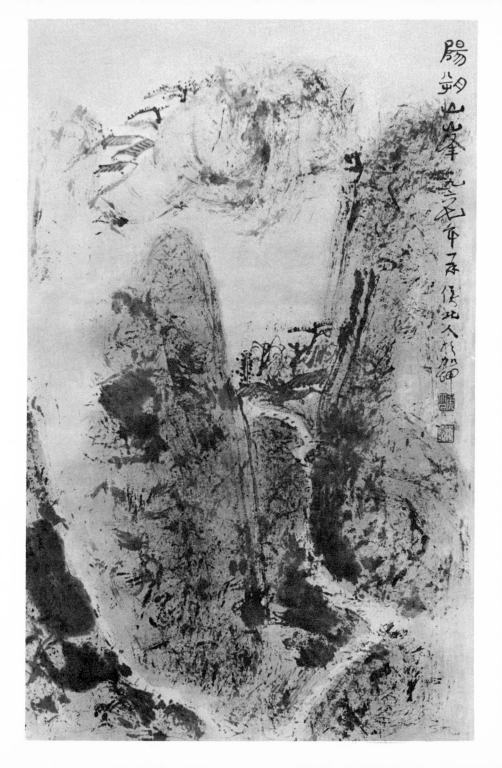

4

My home was at Cold Mountain from the start,
Rambling among the hills, far from trouble.

Gone, and a million things leave no trace
Loosed, and it flows through the galaxies
A fountain of light, into the very mind —
Not a thing, and yet it appears before me:
Now I know the pearl of the Buddha-nature
Know its use: a boundless perfect sphere.

四

我家本住在寒山
石巖樓息離煩緣
泯時萬象無痕跡
舒處周流徧大千
光影騰輝照心地
無有一法當現前
方知摩尼一顆珠
解用無方處處圓

5

When men see Han-shan
They all say he's crazy
And not much to look at —
Dressed in rags and hides.
They don't get what I say
& I don't talk their language.
All I can say to those I meet:
"Try and make it to Cold Mountain."

五

時人見寒山
各謂是風顛
貌不起人目
身唯布求纏
我語他不會
他語我不言
為報往來者
可來向寒山

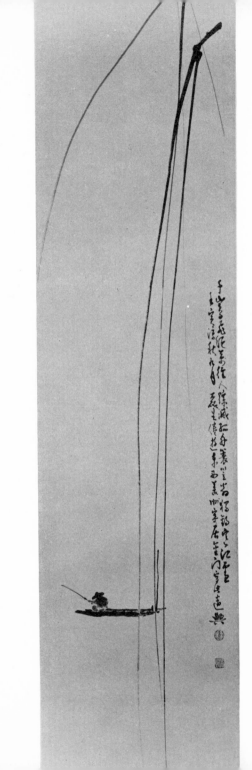

Kai-yu Hsu

MODERN CHINESE POETRY

LUI-SANG WONG: *"Snow on the River"*

ACCORDING to many students of Chinese literature, the best of Chinese poetry is poised in quiet beauty. It persuades without argument; it captures the significant through the insignificant; it creates a world wherein man loses his identity in nature, and together both nature and man find unity and meaning. All this is true of certain masterpieces of the T'ang Dynasty (618-906), the works of such famous writers as Wang Wei, Li Po, and Tu Fu, which are generally regarded as marking the golden era of classical Chinese poetry. But the T'ang Dynasty is only one section in the stream of history. Here are two frequently quoted poems written in mainland China in 1958:

> In Heaven there is no Jade Emperor
> Nor is there a Dragon King in the sea.
> I am the Jade Emperor,
> I am the Dragon King.
> Hey, you Three Sacred Mountains and
> Five Holy Peaks,
> Make way!
> Here I come.

> We sing to the roaring river,
> It rises in thousands of waves.
> Of old, it followed along the mountain,
> Now we make it climb the hills.

> (from *The Songs of the Red Flag,* 6, 172)

Such songs rank with the best of the literally millions of verses being composed today by bus drivers, lathe operators, buffalo herders, foot soldiers, and, of course, men of letters. They express the ecstasy of a people who for the first

time have found expression for their simple but powerful sentiments.

In the crude lines of verse written by a peasant who has just finished his ten-week literacy course in the village night school, there is a cry of joy amounting sometimes to drunken frenzy. The cry may be terrifying, just as a war cry keeping time to the beat of a jungle drum is terrifying, but there is poetry in it also, as the following 1958 poem bears witness:

> One spade shaves off a thousand mountain tops,
> One load carries off two hills,
> One blast overturns a cliff of ten thousand fathoms.

(from *The Songs of the Red Flag,* 93)

The gusto parallels very well Li Po's wild fantasy written, as one of his friends said, after wine:

> One punch smashes the Yellow Crane Pavilion,
> One kick overturns the Parrot Island.

The difference between these two poems is that while Li Po's has always been recognized as an elegant fantasy of a bohemian poet, the modern poem has a savage beauty both serious and stirring. It is the difference between a traditional Chinese man of letters and a ditchdigger, between the allusion-laden classical language and the vigorous speech used by a villager in 1958, between the "higher" and the "lower" planes in the development of Chinese poetry. Mid-twentieth-century Chinese poetry is greeting a triumphal return of the folk song. In these latest verses there is no trace of the restraint, the subdued color, and the refined notes of T'ang poetry. The change is dramatic and needs to be viewed through an historical perspective.

The experience of modern Chinese poetry has been an unrelenting search—a search for man's emotional identity, for a rational explanation of life, and for a new and more effective medium of expression. The search will continue. The poet is, first of all, a man. His sensitivity being superior to that of his fellow men, he is always the most forlorn when an accepted meaning of life is challenged. When events demand a redefinition of man's ideal, the poet is the first to set out in quest of it. The modern Chinese poet inherited certain ideals from his own cultural tradition, of which the most powerful is a combination of Confucian utopianism and the Mahayanist sense of self-sacrifice. He has held the belief that the true value of man lies in his effort to bring order and peace to the entire universe, and he has been impressed by the Buddha's selflessness and compassion that will not let him rest until every creature is saved. These ideals permeate the Chinese mind, and the modern Chinese does not have to be a diligent student of Confucian classics or Mahayanist sutras to become imbued with them.

The nineteenth century unloosed the floodgate of Western ideas on China. Various combinations of Chinese and Western ideas have produced many unexpected fruits. The most vital fusion, however, seems to be of the traditional Chinese ideals and the Byronic variety of romanticism. The Byronic romanticist strives to live intensely, not to pluck the ripe plum while one may, but to get "something done" before the sands run out. The national pathos of twentieth-century China welcomes this variety of romanticism. So much needs to be done, and there is so little time. This may explain the otherwise strange shifts of position among modern Chinese thinkers and poets. The "romantic" Chinese poets of the 1920's followed Byron and Goethe; they searched for pure Beauty as an abstract ideal, and in this search they found meaning for their lives. Their attitude was no different from that of a devout Buddhist who sees beauty only in a transcendental calm and who dedicates his life to its pursuit. The

increasing harshness of physical reality during the 1930's and 1940's drove the sensitive poet to re-identify his ideal, and he reverted, at least partly, to the traditional values of China. He now finds the meaning of his life only in giving life to his fellow men, and the symbol of state as the identity of his compatriots' collective life takes hold of his imagination. One cannot fail to detect this awesome note when Wen I-to cried out in 1928, "This is our China" and described her as "You, the untamable beauty!" Or when, in 1947, Cheng Min stated, with pain, "Ah, China. . . . You are bearing the birth pang for the sake of a more thorough rebirth." Or when a printing plant worker, in 1954, exclaimed upon lifting up a new map from his press:

> This land, over 950,000 square kilometers in
> its length and breadth,
> Every bit of it draws and holds my gaze,
> like a magnet
> Pulling my heart to soar over it.

Behind these lines a state myth has taken shape, and in these voices there is a note that has come very close to religion.

* * *

For a strange and perhaps terrifying phenomenon is sweeping the literary front in China today. The post-1949 era has witnessed the rise of a large number of young poets with very diverse backgrounds. The new leaders in China seem determined to see every front "blossom" at the same rate in the same direction; the rate of dam construction and production increase must be made proportionate to the increase in literary output. Consequently, with every drive to produce steel there has been a comparable effort in the publication of poems. Teams of cultural workers encourage the farmers and laborers to learn reading and writing, and urge them to tell their stories and compose or recite their folk rhymes. The rhymes are then recorded, and, after various degrees of polishing, are published. Literally thousands upon thousands of these verses have appeared in recent years. And along with these verses a new crop of poets has emerged whose names have become familiar in publishing circles and to readers.

The future of Chinese poetry rests in the hands of these younger writers. They are applying themselves to the task with a set of convictions that are extensions of a historical continuum in Chinese literature. The political pressure driving them to go "to the soldiers, farmers, and workers" is by no means the only force guiding their creative energy. As Kuo Mo-jo said with vigor in the early 1920's, many writers of twentieth-century China are genuinely convinced that only by going back to the common people can fresh blood be injected into literature. In a variety of ways the same theme has been re-emphasized by many literary leaders since Kuo Mo-jo. Clearly there has been a reorientation in the aesthetic sense of the modern Chinese poet, and it is futile to try to surmise how much of it has been a conscious effort, or how much of the present result has been sincerely accepted. Without dismissing the political pressure under which Chinese poets are working today, the re-orientation must be faced by any student of modern Chinese poetry as a fact.

The poet who goes to the villages to record folk rhymes remembers another age-old tradition in Chinese poetry. Many emperors in Chinese history maintained an official bureau to collect folk songs as a gauge of public reaction to the administration. Many of the folk songs thus collected have lived on in China's poetic heritage. Some of the songs and verses recently collected from the frontier areas, such as the long story poem *Ashima* of Yunnan origin, have a disarming charm. Even imitations of these folk verses have achieved a good measure of the frontier atmosphere and

flavor. Wen Chieh's "Love Song of Turfan" is representative:

> Young lad under the apple tree,
> Please don't, don't sing any more;
> A girl is coming along the creek,
> Her young heart throbs in her bosom.
> Why is her heart throbbing so,
> So violently, even skipping beats? . . .

(from *Selected Contemporary Chinese Poems,* 202)

The effort to preserve genuine local speech and the question of what is the appropriate amount of literary polishing are in conflict — a conflict that has yet to be solved. Until it is, the reader of the latest poems from mainland China may find them disconcertingly crude. Can this be avoided? One wonders. The process of developing an effective new language for Chinese poetry, which started at the beginning of the century, is still continuing, and its destination is still very uncertain. What appears to be quite certain is the momentum which is at present sustained by the overwhelming enthusiasm of a storyteller or a folk singer who has just learned to write a handful of words. There is no doubt about the fertile imagination of the Chinese, or about the richness and expressiveness of their spoken language. The unleashing of this rich store of creative energy has just begun. The controlled, written vocabulary that illiterate country people in mainland China are being taught to read and write has been sufficient to generate an ecstasy among the laborers and farmers — now that they too can write poetry! They have been initiated into a new world from which they will never want to retreat. This is the ecstasy we hear in:

> Hey, you Three Sacred Mountains and
> Five Holy Peaks,
> Make Way!
> Here I come.

The translations which follow have been selected by the author from his Twentieth Century Chinese Poetry: An Anthology *(Doubleday, 1963):*

死水

這是一溝絕望的死水，
清風吹不起半點漪淪。
不如多扔些破銅爛鐵，
爽性潑你的賸菜殘羹。

也許銅的要綠成翡翠，
鐵罐上銹出幾瓣桃花，
再讓油膩織一層羅綺，
黴菌給他蒸出些雲霞。

讓死水酵成一溝綠酒，
飄滿了珍珠似的白沫。
小珠們笑聲變成大珠，
又被偷酒的花蚊鮫破。

那麼一溝絕望的死水，
也就誇得上幾分鮮明，
如果青蛙耐不住寂寞，
又算死水叫出了歌聲。

這是一溝絕望的死水，
這裡斷不是美的所在，
不如讓給醜惡來開墾，
看他造出個什麼世界，

一九二七年（？）
聞一多全集　丁十六至十七頁

DEAD WATER

Here is a ditch of hopelessly dead water.
No breeze can raise a single ripple on it.
Might as well throw in rusty metal scraps
or even pour left-over food and soup in it.

Perhaps the green on copper will become emeralds.
Perhaps on tin cans peach blossoms will bloom.
Then, let grease weave a layer of silky gauze,
and germs brew patches of colorful spume.

Let the dead water ferment into jade wine
covered with floating pearls of white scum.
Small pearls chuckle and become big pearls,
only to burst as gnats come to steal this rum.

And so this ditch of hopelessly dead water
may still claim a touch of something bright.
And if the frogs cannot bear the silence—
the dead water will croak its song of delight.

Here is a ditch of hopelessly dead water—
a region where beauty can never reside.
Might as well let the devil cultivate it—
and see what sort of world it can provide.

Wen I-to (1899-1946)
1927 (?)

THE SANDALED SOLDIER

You, suffering Chinese peasants, carrying on your back a
 rotten ancient tradition
Under the quickening steps of history, you succumb in
 silence, you struggle;
Power of many kinds rises and disappears; nobody can tell
 how Tao changes;
The different types of guns uniformly rob you of life,
 like a tornado at night

Swooping down unexpectedly, but you could only grope your
 way like a blind man's bamboo cane,
Only let yourselves be kidnaped, and paraded
 through the street,
 Calling all this natural disaster willed by God . . .
That had to be accepted as winter has to be accepted. Finally
 a beautiful change arrives.
Accepting some Christian missionary's words, you believe
 that you have outlasted the days of manacles.

Still you tread in your sandals, marching toward superior
 weapons,
As if walking into a city. You fought guerilla-style as
 though you were hunting wolves,
Bearing the "Sustained War of Resistance" like an unusually
 long monsoon.

Yet you won't boast: The awakening of a gigantic thing,
The shattering of a chain, and that the poets can now sing of
 the dawning,
All depend upon you, "Sandaled Soldiers" clad in gray from
 the muddy fields.

Tu Yün-hsieh (1902?–)

62

草鞋兵

你苦難的中國農民，負著已腐爛的古傳統，
在歷史加速度的腳步下無聲死亡，掙扎；
多少種權力升起又不見；說不清「道」怎樣變化；
不同的槍，一樣搶去「生」，都彷彿黑夜的風。

不意地撲來，但仍只好竹杖一般摸索，
任憑拉伕，綁票，示眾，神批的天災⋯⋯⋯⋯
也只好接待冬天般接受。終於美麗的轉彎到來，
被教會興奮，相信梧桐的日子已經捱過，

仍然踏著草鞋，走向優勢的武器，
像走進城市，在後山打狼般打游擊，
忍耐「長期抗戰」像過個特久的雨季。

但你們還不會驕傲：一隻巨物蘇醒，
一串鎖鍊粉碎，詩人能歌唱黎明，
就靠灰色的你們，田裡來的「草鞋兵」。

<div align="right">詩四十首　一至二頁</div>

活不起

要吃飯，吃不起；
要穿衣，穿不起；
要坐車，坐不起；
要租房子，頂不起；

養小孩，養不起；
爹娘死了，棺材買不起；
鄉下難過活，城裡住不起；
活不起呀，死不起！

一半薪水扣預支，
一半薪水還老李，
剩下一個零頭帶家裡，
去買火油，還是去買米？

<div style="text-align: right">馬尺阮的山歌 續集 一一一頁</div>

64

CAN'T AFFORD TO LIVE

Have to eat, but can't afford to eat;
Have to wear clothes, but can't afford it;
Have to ride a ricksha, but can't afford to ride;
Have to rent a room, but can't afford to sub-lease.

A baby gets born, but we can't afford to feed it;
My parents are dead, but caskets I can't afford to buy.
Too hard to make a living in the country, but can't
 afford living in town.
Just can't afford to live, my friend, yet can't afford to die.

Half of my salary was deducted to cover an advance.
Half of my salary was paid back to Old Li.
Only a little small change was brought back home
To buy what, kerosene or rice?

Yüan Shui-p'ai (1908?—)

大 河也能扳得彎

一根扁担三尺三,
修塘筑堰把土担,
高山也能挑起走,
大河也能扳得彎.

（貴州）

紅旗歌謠九吶

IT CAN BEND THE HUGE RIVER

A pole, three feet three inches long,
Carries dirt when we build a dike or dig a pond.
Even a high mountain it can carry off;
Even a huge river it can bend.

The Songs of the Red Flag, 94

II

Victor Wong

CHILDHOOD II

Photograph by KEM LEE

THE thing that is so puzzling is not to know what Chinese culture *is*. I mean, I'm taught by my parents what it means to be Chinese, and then I watch their actions, and there's so much discrepancy. They say one thing and then they act another way entirely, and so you wonder which *is* the Chinese culture, the way they're actually performing or what they're trying to transmit by word of mouth.

I found the hardest was that there was no attempt to understand a child's being exposed to the mass media of the American way of life, that it actually *shapes* the child. You listen to radio, watch television, read the newspaper, and everything is in English, everything, and so the child *has* to be different; and yet the old folks were constantly trying to make that child a Chinese. They tried to force us to go to Chinese school; tried to force us to speak Chinese, to read Chinese, learn Chinese manners toward the elders, Chinese manners toward one another.... We studied Chinese history—Chinese *ancient* history—the geography of China, Chinese poetry, things like that. Everything Chinese.

But in the meantime, of course, we had to go to English school too. In those days, Chinese school was at least a social form. It was more a clubhouse type of thing than anything else. Of course there was learning; but there was always the feeling of going to a club meeting. This was true of going to church too; these were places where everybody gathered together. There were a lot of picnics, a lot of parties. But English school was quite different. It was just compulsory education, something we had to *do* every day. I was frightened of the teachers, of the

school—just a drag, everything; nobody liked it. Because in the English school they didn't believe in Chinese customs. They tried to dissuade us from speaking Cantonese; they tried to dissuade us from everything Chinese. Their view of the Chinese ways was that they were evil, heathen, non-Christian. So it wasn't until I was in the fifth and sixth grades that I remember speaking fluent English. Usually the teacher would try to teach us English, but as soon as she stopped, everybody would speak Cantonese. It was just continuous warfare between the teacher and the students. She would be *furious,* you know, about our speaking Chinese, because "If you're gonna be an American, ya might as well learn ta speak English;" but Anyway I listened to English, I could understand that better than Chinese; and then at nighttime I would listen to the radio— Jack Armstrong, you know, the All-American Boy; Buck Rodgers, Mandrake the Magician, all those things; and I would send for these badges too, *decoders,* stuff like that. And so I got so I could understand English, in a sort of broken way. But I wasn't able to speak it until I was twelve and a half, not as a means of communication. And the only reason that I learned it then was that I was poor in health and they finally sent me away to a hospital where I was the only Chinese, so I had to learn. I had tuberculosis, which at that time almost everyone in Chinatown had.

So we *were* all immigrants in those days, no matter where we were born. Between the Chinese and the English education, we had no idea where we belonged. Even to this day, if I wanted to say I'm going to China I would never say it that way; I would say *go back* to China. Because I was taught from the time I was born that this was not my country, that I would have to go to China to make my living as an adult. And I think that if it hadn't been for the Japanese War—that is, with the Americans; December 7, 1941—many of us *would* probably have had to go back to China, with our parents. . . . That was the thought we always had. It was always a depressing thought, too, because we didn't know what China was like. It was like going to a foreign country, as far as we were concerned. But the older people, they were always talking about going back home. *All the time.* "When we go back to China we'll have this and we'll have that; there won't be any more discrimination" and all that. . . . And they would be very vocal about *praising* the Chinese culture. They would refer to the white person as—what do they say?—*hone mo guay,* the red-haired or red-beard man or "white devil." Everybody would always be referred to as some kind of "devil," and always with an inferior culture: Chinese oranges were *always* better than American oranges, Chinese *eggs* were always better, everything was always better. The Chinese invented *paper,* and we invented this and we invented that. . . .

And yet there was so much deceit among the older folks. The Chinese in America are a very frustrated group of people and you can see in the internal politics of Chinatown, for example, how much viciousness is involved in just everyday life. In particular there's a very vicious way which is not Confucian at all, the thing I've always hated most. I think this shows up in the language itself, especially in the language between parents

and children. "You shameful thing," they'd say; "you sickly one;" lots and lots of negative words. Parent to child, mostly. And for some reason the parents *never praise the child.* Somebody would say, "Oh, your child writes calligraphy very well," and my parents would say, "Oh—he could do better, this is not really very good." This is a very common thing. I would come home with A's for something and my mother would say "well, we'll see what happens next time," you know; "this is not going to last, this is just a lark." Very, very *down* on the children. They would call the children *toe ju jai* or *jok sing* which means—it's derogatory—an "American born." "American born" was a derogatory term. And of course *all* the children were American born. They'd say, "You're learning the ways of the Western person; You're no good. . . ." It was very, very hard to grow up.

But for some reason the person who was born in China, that is, our parents, *used* the children to vent their frustration on, trying to get us all to *get ahead.* And there was a lot of frustration inside of Chinatown, too, because the Chinese felt themselves to be such noble creatures, and yet they were subjugated, they were discriminated against, they couldn't leave the area, they couldn't buy houses, and so forth; they couldn't get any kind of job. As children we were told not to go to college, because the favorite thing they would say would be, "Here, down the street there's a man who's a Ph.D. and he scrubs the floor, or washes dishes;" where was he to go, you know? There was no place for him to go. They were referring to someone who had gone to an *American* school and gotten a degree. And

couldn't find a job. But we were beginning to see things, especially after the war, that this wasn't so any more; things were opening up. China for the first time was a friendly nation; we were allies. And then, during the war years, everybody was working and making money. Kids seventeen years old could get a job in the ship-yards or something; there was a shortage of labor. So the Chinese began to be accepted by the American public. And then kids would be in the same outfits and got to know each other, so that after the war kids like myself would begin to bring non-Chinese into the area, bring them home. Which was a very hard thing to do, even then. Even today it's very hard. They say, "What're you hanging around with the whites for?" Very, very strange people. Very prejudiced, racially.

But things were opening up. And so there began a period of rebellion that came along with the natural rebelliousness of a child, growing up into a teenager. Especially in our late teens, when we were seventeen, eighteen, nineteen years old, in the late 40's and the 50's, there was endless discussion about what to do about the dilemma of being *caught in between* . . . being loyal to the parents and their ways and yet trying to assess the good from both sides. We used to call ourselves just a "marginal man," caught between two cultures, not knowing which is better. Even today the same thing still goes on. There's still that feeling of not knowing which way to go.

In the end, though, it was because there was so much *hypocrisy* that I finally turned away from Chinese culture for so long. Because as a teenager I began to see that it wasn't quite right to be constantly talking against the American

culture, you know, the American way of life, because I could see from the way my parents were and other adults that they weren't really living the Chinese life. They would talk about how we would have to grow up following the Confucian ways, the Taoist ways, and yet there was *nobody,* no Chinese man or woman that I could look up to.

And so I left and went away to college. But actually, in my mind, I had left Chinatown long before. . . .

And yet, finally, in the last two years, I have begun to realize that I really can't find a place as a human being by just constantly knocking Chinese. So in a very deliberate way I have decided to come back into the Chinese culture. For instance, I got a job with an engineering firm in which all draftsmen were Chinese. *All* of them born in Hong Kong or Formosa. And they all spoke Chinese. My own psyche released all that I had been taught of the language, and it was really strange; in a very short time I remembered everything. And today I can go to a Chinese restaurant or approach people in Chinatown and converse in very fluent Cantonese. They're all very amazed; most people of my age, the ones born here, no longer speak Cantonese.

But the funny thing is that after I consented to return to the culture I felt much better as a person. And much easier to live with. . . . Much more quiet inside myself since I returned.

Nanying Stella Wong

KONG CHOW, USA

*Composed against the destruction
of the Kong Chow temple
San Francisco, March 1969*

Yee Ah-Tye, Kong Chow to Plumas County
claimed in 1854 land from city fathers;
this he donated
to Kong Chow community —
to the yees, chans, wongs, lees, and fongs —
KONG CHOW BENEVOLENT ASSOCIATION
AND ASYLUM, U S A !

he put a temple into this haven
to thank the gods for the sailing vessel journey
COMPLETED across waters of Great Peace!
beneficent feng sui,
spirit of wind and water!

the temple stood benevolently
eyeing the serene waters before her
the seaport town's winding hills behind
— the Dragon's serrated backbone
Great Spirit linking heaven and earth!

FENG SUI! FENG SUI!

the temple was swallowed in the Fire, 1906
everything was destroyed
except the huge bronze bell
they found it at the bottom of the crater.

Kong Chow AROSE from the ashes . . .
bell gleaming like it was
first cast in Canton
to this day
this hour.

73

"WE ARE NOW CALLED KONG CHOW
 FRIENDLY SOCIETY, BOARD
OF 45 DIRECTORS, 15 ADVISORS —
 OF WHICH I AM ONE!"

he plants his two feet firmly on pavement,
 scanning 1969 scene:
 "our Feng Sui no longer beneficent
 that mighty bank building spring
 across courtyard —
 blots out water —
 still rising
 to put out our sky!
 a few years ago other
 directors wished temple
 moved to sacramento street
 I OBJECTED
 sell it for profit with no-good Feng Sui?
 TODAY
 Bank of America jabs the sky with 52 stories —
 block our Feng Sui water view! kill our
 prosperity!
 so I turn — now vote for its immediate sale!"

"my father was given a sizable parcel of land
 by those who could give land away,"

 smiles Yee Oi-Tai, 97 years old,
 first chinese social worker here.
 "i have heard Kong Chow Association
 about to sell property on pine,
 with the money, pay for another
 lot to build temple closer
 to worshippers . . .

I am the daughter of YEE AH-TYE,
 the man who gave this land to Sun Kui-Yuen
 to all the people from Kong Chow district
 over a hundred years ago. I strongly OBJECT
 to the exchange. i do not wish chinatown congested
 like a ghetto, i believe chinatown should
 s p r e a d — not shrink!"

father used to say at dinner, "Oi-Tai love,
 i gave our land
 to the people — for their comings and goings —
 between Kong Chow
 and U S A . . ."
 "father has . . . that . . . that ghastly scar
 down his left cheek . . .
 why, mother?"
 "he was knifed . . . daughter . . . knifed
 because he would not
 give the land only to the yees."

 the grandson stands up, shoves his hands
 into his pockets:
 "grandfather Yee Ah-Tye migrated to this country
 middle of 19th century; settled in
 la porte, plumas county;
 an early pioneer, he played
 important role in goldrush days.
 realizing
 hardships of other pioneers soon to follow,
 donated this land to Chinese of san francisco
 for construction of a building, his fondest wish
 it serve as temporary shelter . . .
 and a temple be built
 for those who wish to worship.

the landmark is historical, ground hallow;
 preservation of this property should
 be permanent. relatives and descendants
 join me in that ultimate desire.''

great aunt Oi-Tai! i see
 the shadow of monster-crane, bulldozer
 gape of power shovel . . .
the temple and haven your father gave
 its lanterns missing,
 embroidered drapes fading,
 marble inscriptions chipped —
 padlocked rooms

 r e d u c e d to a plaque!
"benevolent association" a mockery!

 20,000 arrivals from hong kong per year
 rejoin kinfolks on new humanizing
 Immigration Act; 5,000 to san francisco
 chinatown's cubby holes, community kitchens,
 baths . . .
extra children sleeping on top of chairs
 six to eight in a room
 their tongues not yet trained
 to a syllable of English!

"when will concerned America *emerge?*"
 asks Save the Kong Chow Temple lawyer;
 "we now have a goldrush of another sort . . .
 many people coming in . . . need English

before they can learn skills to
 take their place in New World.
 the real issue — what are Kong Chow directors
 going to do with the money —
will they use it to help our needy people?''

young architect representing fellow students:

 "we think there are other ways of using site
 rather than selling to private developer,
ways more in spirit of original donor . . .
why not use money — initiate housing development
for wide community
 Kong Chow Housing Development
 Temple and Public Service . . .
 or we investigate
 ways of making temple
 into complex — encompass facilities
for cultural activities,
 education, recreation — tie all
with Sun Yat Sen statue at St. Mary's Square . . .''

Kong Chow trustee shouts loud and hard
 from his papers,
 "our records show
 Yee Ah-Tye exchanged temple site
 for 22 acres of farmlands in China
 therefore our obligation
 to donor and his family
 acquitted by this trade!''

75

flipping more sheets the trustee
continues, "furthermore
the site is *not* original
the temple *not* historical!"

turning page after page from law book,
to "as ifs" and "whereas," words, words,
another director drones.. . . .
to prove Kong Chow Friendly Association
is owner of Kong Chow Temple.
their mass refrain in headlines:
"Kong Chow trustees claim Yee Ah-Tye
swaps temple lot for 22 acres
farmlands in China! SWAP! Only a swap!"

we have no legal papers,
no documents at all—
only the spoken words,
same old words which spin out
of great-aunt's thinning lips,
no papers, no law books, no documents
at all—everything burnt in the Fire;
only the words, spoken from the heart
of Yee Ah-Tye, after a hundred dinners
back in goldrush town of laporte, plumas county:

"Oi-Tai, love, i have given our land to the people
for their comings and goings and for a place
to worship . . . from Kong Chow
to U S A . . ."

"the crazy fools! i never heard of it
no one in my family ever heard of it—
from the time my father stepped
on this soil he never wanted
to return to China—we the children
have never gone back to live . . ."

grandson shifts his foot,
"my mother told me—a delegation
of Kong Chow trustees went to
stockton where she resides
to make this offer—some
80 years after grandfather's donation;
mother said farmlands were all under
communists' hands, and of no use to us."

Kong Chow Temple cradled
in leaping technological giants,
protected by images of two general-guards,
her great double doors swing open
to an endless corridor of space
to a courtyard of tranquillity
of a n o t h e r t i m e . . .

Lily Tom

RECONCILIATION

TO be responded to is to have one's existence validated. It is to emerge from nothingness into existence in the eyes of others. To be loved is to be responded to; it is an affirmation of one's existence. Fame and notoriety are but shadows of this affirmation. Perhaps what is worse than being hated is being ignored and feeling that you are not real to others; and because you are not real to others, you are not yourself convinced of your own reality.

A person feels truly alive when he has struggled with a problem with his whole being—he has responded fully to an event. If he responds with his whole being, he is transformed from nothingness to positiveness; he emerges from a vast grey void into existence. A problem is an imperative— it demands a response. It is a situation or event for which you have no habitual answer. In finding a solution to the problem, you must respond as you never have. Because you respond, you feel alive. It is not often that something demands a response, and hence we often take no notice of the things around us. We do not respond to the tree and moon because they are not problems.

To respond fully to an event or thing in all its complexity is to affirm one's own existence and the existence of something "out there." Suddenly what is "out there" becomes real because it is no longer "out there" but within your consciousness. What was external now becomes internal, for it has become part of you. What was a thing has become a happening. A thing is not real to you until you respond to it and confirm it yourself.

Society defines reality for us by giving names to things. It gives the tree its name, it gives us the name of "male" or "female" — everything it considers important it gives a name.

To persons who have no other reality except society's version, naming a thing implicitly confers reality upon it. But actually naming is an excuse to ignore a thing and not to respond to it in all its uniqueness, complexity and wholeness. We are asked to respond to only one aspect of a thing—that aspect which goes with its name. We think of a cabbage as strictly food and never something to look at. A wild rose is to look at; we do not think of it as something to eat. When we are asked, "Who are you?" we automatically answer with our name. But what are you without your name?

To name a thing is to say that a thing *is* its name. Yet a moon can be other than a moon, a tree other than a tree. The wonder of a tree lies not only in its being a tree in all its uniqueness, but in its being other things as well. A moon can be many other things even though it is a moon. A child who does not know that that yellow disc hanging up there is a "moon" might see it as a toy, but a child who has learned that it is a moon might not. To see that a moon can be something else requires responding to the moon without regard for its name and what that name implies.

To give a name to a woody perennial plant is to differentiate it from its environment. But at another level the woody plant cannot be so easily uprooted. It needs the soil, water, air, sun for its sustenance: it *exists* because of them: it is part of the earth. A thing cannot be separated from what is around it, although the peculiarity of naming allows us to isolate it. This isolation exists in our minds and is not necessarily confirmed by other levels of awareness.

When an event or phenomenon is given a name, it becomes a thing. A chasm has been created between the thing named and other things. While society seems to define reality by giving names to things, it is actually slicing up and processing reality for us. Consequently we are prevented from experiencing reality ourselves. Once reality has been sliced up for you, only you as a whole—not your eyes or your intellect alone—can repair the damage and put the pieces back together again.

You do not see with the eyes; you see with your being. Responding with our whole being means seeing, but not with our eyes; hearing, but not with our ears. It means to read a book without words, to hear music without sound: it means sensing color in sounds and sounds in color. A man who does not respond to the motion and power of the ocean waves is at that moment without motion and power.

When you respond fully to a person or an event, you are no longer aware of yourself. When you are no longer aware of yourself, gone is the need to have your own reality confirmed by others. For there is a reality which is greater than your self. He who loses his self finds it in a larger, nameless self.

II

The scene is traditional China, probably the Ming dynasty. The heroine is a beautiful young woman with a sweet, almost ingenuous face. She could be the daughter of a magistrate or official. But we find that at night she is the mysterious

RUBY LEE: *Chinese Girls*

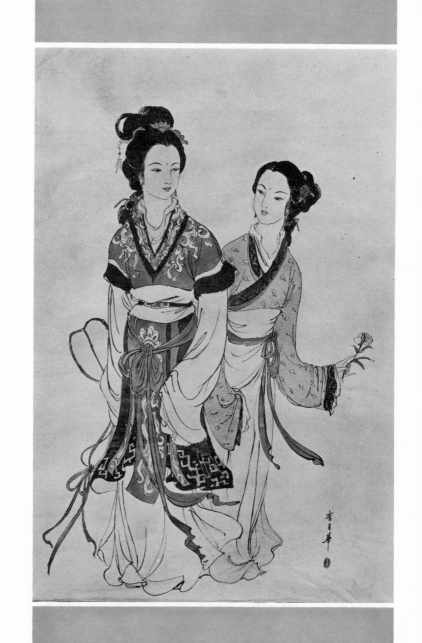

masked bandit Black Butterfly, highly skilled in swordfighting and acrobatics, who robs the rich to feed the poor. In conventional life she is a waitress in her father's inn. Although her father is a master of the martial arts, he is unaware of her expertise and other identity. She is admired at a distance by her father's star pupil and by one of the leaders of a group of bandits. In the end, side by side with this pupil and others, she fights against that group and encounters the bandit leader who, not knowing her secret identity, would seize her for his bride. Far from forcing himself upon a defenseless girl, however, he is now clashing swords with a formidable opponent who finally kills him.

This is the plot of a recent Chinese movie, *Black Butterfly,* one of a genre which contains an image of woman without counterpart in the West. We see a woman attractive and feminine in face, figure, and manner. While her costume is pleasing, we are hard put to distinguish its style from a man's. Her voice is restrained and soft; her face is often sweet, sometimes even ingenuous, but never provocative. Yet on closer inspection we find this physically gentle face animated by daring, aggressiveness and self-assurance, sustained by a competence in swordplay which equals or surpasses that of the men. She is compelling as no traditional woman ever can be. She seems to have usurped the role of a male.

Our Chinese heroine is a man while being a girl: she is both male and female. She performs what we consider a masculine function. Typically, her duty is to avenge her dead parents or family *(Blood Flower Sword, Jade Dragon).* Or she fights for the underdog, virtually alone or with the other swordfighters *(Black Butterfly, Hero of the Heroes).* In a reversal of the hero and heroine roles found in Western romance, our Chinese swordswoman often saves the hero from

Opposite: *Scene from* Thirteenth Sister, *which appeared in American theaters as* The Young Avengers.

death or serious injury through combat. When she is about to be molested by a man she acts swiftly, aggressively and effectively. In all cases she acts as a person, not as a woman. Never is her biological status a justification for evading her duties as a member of her family or her society.

In contrast, the traditional woman does not act; she is an object which is acted upon. While this object is cherished and adored, woman as object is nothing if she does not belong to a man. Only a man can confer reality upon her or justify her existence. The sleeping beauty awakens only upon the kiss of a man.

The Chinese swordswoman puzzles us because she is a hero, not a heroine in the Western sense. She does not wait for the hero to support or rescue her or justify her existence. Her masculine heroism stamps her as actor. She exists in her own right. She is the antithesis of the traditional Western heroine, who is incomplete in herself and is object.

* * *

Style cannot be separated from function. While the style of the Chinese swordswoman's costume is not feminine, it nevertheless reveals the femininity of her figure. The function of the traditional woman, on the other hand, is to please and serve, sexually, visually, and socially; and her costume, by immobilizing her body, creates an image of woman as a passive, languid object. Heels, straight skirts, stockings and such interfere with the fluidity of the wearer's movements or seriously hamper or prohibit certain types of movements; they anchor her in one place and freeze her in uncomfortable positions when she is sitting or standing. Such a costume goes far beyond accentuating physical femininity; it *creates* a sort of femininity which flaunts itself upon the viewer, an artificial femininity which resides not in the figure but in the costume.

On the other hand, as our Chinese sword-fighter's function is the same as a man's, her costume seems to be masculine. But it might be more accurate to say that the style of the sword-fighter costume shared by both sexes is neuter, for it is designed above all for function, not for appearance. It is not designed to emphasize sexual characteristics or to maintain an image, and thus it can be worn by both sexes. Yet the feminine form of the Chinese swordswoman is apparent despite the costume.

The swordswoman's function is not to please sexually and visually; it is to act swiftly and with agility. The aesthetics of her form takes on an added dimension, for the agility, fluidity and grace of the human figure in action are harmonized with her feminine characteristics. The female form here is not static as in the case of the Western woman; it moves and lives as the ocean waves and tree tops move in response to their surroundings. It is not just the female form we see, but the whole human form in action.

* * *

The heroine of *Blood Flower Sword* and *Single-Armed Swordsman* appeared in the role of a traditional Chinese wife in another movie. The star of *One-Eyed Swordsman* and *Saintly Knight* has also played an ingenue role in a recent modern-dress production. Both the traditional roles are complete with downcast eyes, shy looks and self-constraint. There is no doubt about it: the same individuals are bland in one role and vital in the other.

In two other movies the sheltered daughter of a high-ranking official was forced to disguise herself as a man. Disguised, she was transformed from a show-case doll into a living person. The traditional role had suppressed some of her qualities and abilities. Once that role was abandoned,

she changed. Her new role created new demands. She became more alive because she was forced to respond, to act.

Not only are functions designated as "masculine" or "feminine," but also the style of their performance. Traditionally, a woman can act out "masculine" intentions only while *being* a woman, that is, only covertly. From this denial of the masculine in woman has developed a whole pattern of feminine wiles and manipulations— tears, charm, sex, and covert, unconscious aggression from which not even husband and children are exempt. The traditional woman asserts herself by suppressing herself and regressing. She conquers, not by conquering, but by letting herself be conquered. By being masculine only on the covert or unconscious level or in a feminine style, she deludes herself and society that she is completely feminine. On the other hand, when our Chinese swordswoman acts like a man she is not half-hearted about it—she is completely and overtly masculine; she does not hide her actions under a woman's guise. The end results may be the same; the styles are utterly different. Our Chinese swordswoman assumes a masculine role and masculine style while retaining her natural femininity. She is more complete as a person because she embodies what we think of as warring opposites— masculine and feminine. The "traditional woman," trying to embody "pure femininity," is a fiction. Our Chinese swordswoman is her own creation.

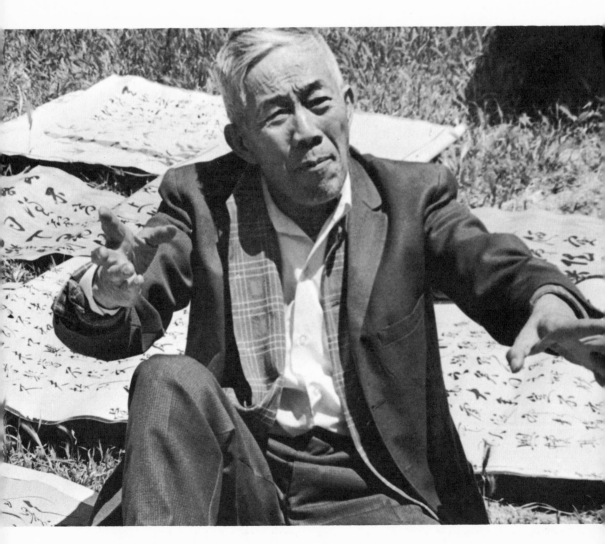

Loni Ding

DOCTOR MAH

Photographs by VICTOR WONG

THE encounter between traditional China and California has taken unlimited forms, one for every life-style and personality. Dr. Mah Ton— folklorist, poet, healer and visionary, gadfly and showman—is his own variation on this theme, making his style of life itself the crucible in which two cultures are unified.

Third generation in a line of Chinese herbalists, Dr. Mah came to California in 1924 to apprentice himself as a butcher to a distant relative. It was a common pattern and a common hope: get to America, make some money, then return rich to your family. Passage was relatively cheap then, and it was not uncommon—especially between port cities like Hong Kong and San Francisco— for a man to commute regularly to China. Mah, too, despite the wars, went back every seven years to his wife and children. Yet always he has returned, a sojourner in two lands.

World War II found Dr. Mah in Bakersfield: turbulent war years, especially for a foreigner, when things seemed all upside down. Restless, cut off from his family and no other ties to bind him, Dr. Mah traveled: L.A., Houston, New Orleans; Mississippi to Arkansas; then up to Chicago, Seattle, Portland, down again to Arizona, making his way as a "medicine man for all ills, physical, mental, spiritual," with fortunes, proverbs, and herb prescriptions for all, Chinese and non-Chinese alike, to be filled from the far-off herb stores of San Francisco. Success and failure alternated; as always, Dr. Mah survived by his wits, doing odd jobs when his luck was down until some new benefactor, recognizing his ability, would again stake him capital for a fresh venture. He was on the road this time for four years. Then, the war over, he went back again to China: this time to Canton, where he took up a more

intensive study of herb medicine and began formal study of calligraphy and painting as well, studying under various masters who took his fancy.

This was in the 50's; Dr. Mah was over fifty years old. In the last twenty years the established medical profession's antagonism to Chinese herbalism has driven him from Honolulu through L.A. to San Francisco to practice his craft. Now he has retired to relative seclusion in Oakland; but his exuberant outlook continues to overflow into his practice of diagnosing and prescribing for ills wherever he finds them. In the 50's, for example, reading in the newspapers of Eisenhower's illness, Dr. Mah made his own diagnosis and sent the President some herbs. An exchange of letters followed, and Mah seized the opportunity to call the President's attention to the exclusion of Chinese studies from U. S. schools. As usual, Mah was ahead of his times. His suggestion was a forerunner of the now modish demand for ethnic studies.

Dr. Mah is, in fact, a constant writer of letters to everyone, newspaper editors, the Mayor, the Governor, the Police Chief, the Presidents of the United States, criticizing social injustice and offering his own sweeping, utopian plans for civilized reform. In particular, Mah has been a consistent critic of the tight Chinese power structure whose self-interest or inertia has helped to foster and preserve the sub-standard living conditions of modern Chinatown. At one time, like Martin Luther with his ninety-five bans nailed on the cathedral door, he wrote his indictments of the Chinese Six Companies in magnificent calligraphy on huge long scrolls which he hung from the trees in Chinatown's Portsmouth Square Park; then he stood around for the rest of the day to talk to sympathizers and answer critics. For this and similar incidents he was severely

castigated and even, Mah alleges, brutally beaten by goons hired by his opposition.

But Dr. Mah goes on speaking out his criticisms and proposals. His latest plan—really an old dream revitalized—calls for a complete reorganization of core Chinatown to start with, block by block, into a cooperative network capable of providing the Chinese community with the social services and mutual protection it so desperately needs. Thus all Chinese families might be drawn into mutual interdependence instead of competition. Eventually, as Mah intends it, this reorganization would grow into a close cooperative union of every Chinatown in the U.S. "It is an old Chinese idea," he says, "for cooperative peace and security"—similar to what the Chinese Six Companies and Family Associations originally set out to do but since abandoned for political power. Present-day Chinatown, however, is so fragmented, so mutually suspicious and competitive, that Mah had pretty much abandoned this plan as impracticable—until late last year when the Chinese New Year Street Fair gave his idealism new hope.

For the last several years the street events of Chinese New Year—the concession stands, vendors, and such that used to line the two-block length of Waverly Place to accommodate the great flood of tourists flowing in every year for the parade—have been farmed out by the Chinese Chamber of Commerce to non-Chinese, professional carnival men from as far away as L.A. This practice, mutually profitable in thousands of dollars to the concessioneers and the Chinese Chamber of Commerce, meant the effective exclusion of the rest of the community from participation in both the making of the celebration and its profits. Also there was always trouble in the streets, since the event invariably attracted outside street gangs which the hired

87

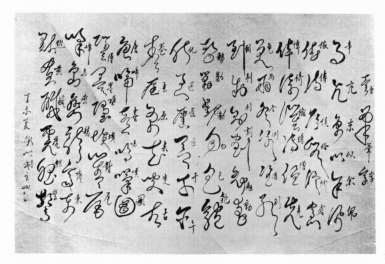

MAH TON: *Calligraphy in the* tsao-shu *style.*

police force was unable or unwilling to cope with. Medical attention for spectators during the event, also left up to outsiders, was equally poor. All in all the practice of turning over Chinese New Year to outside profiteers was disgraceful, costly to everyone except the CCC, and bad for all levels of the community.

Late in 1968, fed up with this situation, the Chinatown-North Beach Youth and Recreation Committee, a group of youth and recreation professional workers, took up the fight of "requesting" that the Chinese Chamber of Commerce rescind its old profitable arrangement for the good of the community. To the credit of the Chinese Chamber of Commerce, backed to the wall by public exposure in the media, the concessioneers were dropped. The Youth and Recreation Committee, in collaboration with the San Francisco Art Commission's Neighborhood Arts Program, then proceeded to organize its own

New Year Street Fair for 1969. Some fifty or so grass roots organizations like the church youth groups and the YMCA joined in. In addition to strictly local organizations, help poured in from Chinese college and university students from all over the Bay Area. Mah himself was so impressed that he donated his paintings to the event, made special decorative scrolls, composed and calligraphed some couplets traditional to the New Year for a parade float, and manned his own booth as a calligrapher and fortune-teller with the help of a brightly-painted pet rooster he had trained to tell fortunes and respond to commands. Talk of cooperation and a Chinese "community" began to make some sense again. Dr. Mah returned to his old plan, and his criticisms and suggestions have gained the attention of the Mayor's office in its recent investigation of China-town conditions. "Only those people who don't have vision will think I am crazy. If you have any vision at all, you will understand."

In all these plans and social criticisms 72-year-old Dr. Mah aligns himself consciously with the youth of Chinatown, of all cultures, who acknowledge the kinship immediately. Frank, iconoclastic, volatile and self-reliant, simultaneously practical and idealistic, Dr. Mah has no difficulty understanding and being understood by the younger critics of Chinatown today. He is unconcerned about the common Chinese criticism that the American-born youth are becoming "too American," losing sight of their Chinese identity. "We *are* Chinese," he says, "physically, racially, culturally. We already look and feel too different for there to be any mistake. There's no chance of becoming too Americanized."

But it is in his art that one guesses the significance of what Dr. Mah has worked out. There, as in his style of living, the man is unbound by any formal conventions. Traditional techniques and subject-matter are his starting points, but the outcome is never traditional; it is only consistently surprising, inescapably Chinese but shot through with the avant-garde—something here like surrealism, there almost straight camp. "The true surrealism is a direct expression of the mystery at one's own heart:" Mah's style grows out of his own self-explorations, not from the experiments of the West. Poems written in the classical styles, maybe even by the ancient masters themselves, emerge in a highly vigorous and idiosyncratic hand, as if the artist were dissatisfied with all the traditional calligraphic forms and scorned to use them; often they are accompanied by bright and irrelevant tigers or other fanciful scenes, all turned out voluminously, carelessly, exuberantly on huge scrolls of anything at hand, shelf paper, wallpaper, window blinds, anything "interesting," to lie around

forgotten afterwards in the corners of many rooms. It is as if he is too impatient, too restless to stay with any one technique or form. His experience, anchored in Chinese ways of thought, is of the United States as well; he suspends them both, past and becoming, in a free-wheeling, precariously personal balance that would collapse if he ever slowed down. Nothing holds him, no country, no school of thought, no motive. Work done is past; Mah does not live in the past. If all his paintings, all his poems were destroyed overnight—and many have been lost, given away, destroyed—he would not care: he doesn't live there any longer; he would simply go on creating more. Cut off from the old world, Dr. Mah moves on, binding his roots to what is young and emergent in the new.

IN many ways, the year 1968 signals the beginning of a new era in Chinatown after two decades of radical internal social transformation. This transformation did not take place in isolation, as some would like to think. Rather, it took place under the influence of the so-called "American Negro Revolution" and the U. S. policy with regard to Red China. The militant black movements, and to a certain extent also the white radical movements, have exerted most influence on many Chinese-Americans at the high school and college levels; the U. S. foreign policy has had most effect on the older generations.

1. CHINATOWN IN THE PAST

Chinatown of today cannot be understood apart from Chinatown of yesterday; problems of today cannot be solved without adequate understanding of their history. Who were the Chinese who migrated to the U. S. in the second half of the 19th century? What were their culture and aspirations? To what extent were they in contact with white society and affected by the American political, economic and social order? What were the factors that affected race relations? What are the factors that have caused the sudden influx of Chinese immigrants since 1962? These are but a few questions of vital importance not only to historians and social scientists but also to those who live and work in the community.

The Chinese migration to the United States in the nineteenth century follows the same general pattern as Chinese emigration everywhere. Seeking new economic opportunities and escaping domestic hardship, many *huaqiao* (overseas Chinese) went to Southeast Asia and other continents with the intention of returning eventually to their homeland. Many others were recruited or kidnapped as cheap laborers to California by

L. Ling-chi Wang

CHINATOWN IN TRANSITION

Illustrations: *Students of Domenic Domare at Francisco Jr. High School, San Francisco. Each student was asked to make a mask of his own identity: how he pictures himself to himself. (Photographs by* CHRISTA FLEISCHMANN)

were many who changed their minds about returning and became permanent settlers in foreign lands. Those who came to the U.S. from the province of Guangdong were no exception. Some regarded themselves as sojourners, others decided to become permanent settlers. The unbreakable bond between the Chinese and his homeland and culture was a decisive factor in the development of the sojourner attitude, greatly reinforced by the dissimilarity of cultures and racial features and the outright discrimination and persecution of white Americans.

External and internal influences both thus led to the creation and preservation of a duplicated Chinese society or ghetto on foreign soil — a society of sojourners and permanent settlers strongly oriented toward China, and looking to her, vainly and helplessly, for leadership and protection in times of persecution. In spite of distance, direct or indirect communication between Chinatown and Guangdong was kept open at all cost, as it is even to this day. In most cases, it should be noted, only male members of the family came over. Family affairs often were maintained across the ocean, but occasionally by commuting. Many fortunate *huaqiao* soon retired to China; the less fortunate ones had to be shipped back. Others established families in this country. Those with families sent their children to Chinese language schools in Chinatown or to schools in China. In short, the transplanted Chinatown ghetto was established to assure cultural continuity with homeland Guangdong and to provide a temporary shelter for an oppressed people.

To the surprise of no one, then, the unique Chinese patriarchal family system was to be found on American soil in spite of its obvious cultural and economic incompatibility. Within each family, the grandfather or father, the absolute head with sole authority over all members of the family, controlled, arbitrated and looked after family affairs and made financial decisions. The concept and custom of ancestor worship, of course, enhanced his authority and perpetuated family solidarity and stability. This basically Chinese agrarian concept of family was somewhat functional as long as Chinatown remained insulated from cultural and economic entanglements with the greater society. Close ties with China were meticulously sustained and children were not exposed to American education and to such alien concepts as freedom and individuality.

Closely related to this concept of family was the century-old feudalistic concept of *zú* which was the heart of the Chinese patrilineal kinship system. A *zú* included many families, all descendants of the father's line. *Zú* formed the basis for preferred social interaction, extension of mutual aid and protection, pattern of migration, and occupational choices. The male head took care of *zú* matters such as sacrifice, cemetery, property, disputes, and inheritance. From this concept were developed the family name associations, now numbering 44, which controlled the families of the same *zú* and rendered various services to its members, especially in problems connected with immigration and family disputes. As time went on, however, with the rise of new generations and increasing mobility and contact with the white society, these associations gradually lost contact with and control of the very people they were supposed to control and serve. There is no indication that the still younger generations of the present will join these outmoded organizations at all. Thus, on the family and *zú* levels, the trend has been increasing departure from the elaborate traditional kinship system to more economically and socially isolated family units.

The same loss of touch with changing reality could be said to be true with regard to the forty-three district associations and the Chinese Six Companies, an amalgamation of seven major district associations: Ning Yung, Kong Chow, Shui Hing, Hop Wo, Yan Wo, Young Wo, and Sam Yup. Originally founded for the purpose of serving and protecting immigrants of the same district and linguistic background, these associations became increasingly obsolete as the great concentration of Chinese in the small urban ghetto forced them to abandon the provincialism of rural China and become a more integrated and homogeneous Chinatown.

Thus the transplanted, closely-knit Chinese community began to take root in the 1860's and 70's. Considerable cultural, social, and economic intercourse between the Chinese and the white people and permanent settlement of many more immigrants in the U. S. could have been possible had it not been for the blatant display of white racism in the form of discriminatory legislation, lynchings, mass riots, massacres, mass deportations, boycotts and persecution of all sorts. Limits or restrictions on social contact, communication and relation imposed upon the Chinese minority soon erected an inpenetrable social, political and economic wall around them. Contacts with the white society were minimal; the link with China was at best superficial. In general, Chinatown became quite oblivious—not by choice—to the Western way of life, while remaining almost equally unaware of the modernization and cultural reforms taking place in China. In this way, many traditional village customs and practices, values and judgments, attitudes and ideas were preserved in Chinatown long after they had been abandoned in modernized urban centers in China. Little wonder that today, many

recent immigrants from Hong Kong find Chinatown somewhat backward, narrow and strange in many ways.

The symptoms of prolonged ghetto existence were many. The universal use of dialects in Chinatown created an insurmountable language barrier and deficiencies among students and adults alike. The language barrier deprived many of the right of basic education, limited employability outside Chinatown, and caused high rates of unemployment and under-employment in the ghetto. Language deficiencies and "speech defects" often retarded the learning process and contributed to the development of feelings of inferiority and frustration, frequently resulting in truancy, dropouts and delinquency. Children were brought up under two systems of political and cultural indoctrination: American white, middle-class and traditional Chinese values. (To this date the school system has yet to recognize this conflict and create a meaningful cultural and social bridge between the two systems.) The high density of population, second only to Manhattan, created a severe housing shortage, relatively high rents, and rapid deterioration of housing conditions, while the early pattern of migration (predominantly male) and subsequent anti-Chinese legislation prevented normal family life for thousands. Economically the Chinese were consistently limited to menial occupations, small family-oriented businesses, and light industries — grocery stores, sewing factories, arts and gifts stores, etc. Politically, they were apolitical, indifferent, and therefore powerless. Traditional distaste for politicians, lack of political sophistication, and discrimination by and large excluded the Chinese from the political life of this country.

More devastating than this kind of degrading existence was the gradual development of an all-pervading ghetto mentality among the Chinese of

all age groups. In general, most Chinese were unaware of and apparently indifferent to and unconcerned about the social, political and economic activities of the greater society and quite ill-informed about their own community. In their struggle for survival, they were forced to share the limited economic opportunity and resources in the ghetto. Wide-spread feelings of entrapment and powerlessness created an atmosphere of mutual distrust and exploitation, in which the necessity for survival bred a fanatic desire for self-advancement even at the expense of friends and relatives. Unable to deal effectively with whites, the ghetto Chinese learned willingness to play an inferior role in the white society, and to tolerate—sometimes even pursue—injustice and the status quo. Unfortunately, this ghetto mentality is still in full operation today, even among the successful professional men and progressive individuals.

2. FACTORS FOR COMMUNITY CHANGE

The beginning of internal social change came during the Sino-Japanese conflict (1937-1945) and World War II, when anti-Chinese sentiment gradually subsided. Better educational and economic opportunities outside of Chinatown gradually became available. In spite of continued practice of discrimination in employment and housing, more and more Chinese were able to secure better paying jobs and acquire properties outside of Chinatown. Thus began a continuous exodus from the ghetto.

However, the most basic internal changes did not take place until 1949 when Communists took control of China. As mentioned above, the established Chinese society in San Francisco assumed uninterrupted communication and cultural continuity with China. It further assumed a normal diplomatic and trade relation between China and the U. S. When Communists took control of

China in 1949 and the U. S. imposed a quarantine on China, the Chinese community was forced to make a drastic re-adjustment or re-orientation. For many, the experience of being cut off from their homeland was traumatic; for others, total re-orientation was difficult and painful, if not impossible. The sojourner *huaqiao* now had to become permanent settlers by becoming either U. S. citizens or, as many still prefer, permanent residents.

The immediate effect was the emergence of new American-born generations who were more than ready to be successful in the white society. Customary emphasis on Chinese language and old-world culture quickly receded to the background; often being Chinese was degrading because it reminded many of a heritage of deprivation, humiliation, maltreatment and discrimination. The loss of the Chinese tongue, not to mention wide-spread illiteracy, became a common phenomenon, even among the tradition-minded members of associations. Public education, based solely on white, middle-class values, ignored and suppressed cultural differences.

But older generations that never had the opportunity of citizenship, basic education and another value system greeted the new generations with perplexity and sometimes with jealousy, suspicion, or contempt. Most of them were too old to adjust to the new environment and to adopt a new mode of existence. Tension mounted in families, schools and the community as the Chinese underwent a complete re-orientation. Unfortunately, the schools, community and government took no notice of this situation, and it was, therefore, only a matter of time and additional strain—the influence of civil rights movements, community action programs, and the new influx of immigrants—before the tension erupted in public.

While Chinatown was going through this period

of re-orientation and social transformation in the 1950's and 1960's as the result of the Communist takeover in China, it also came under the influence of the civil rights movements and the subsequent demands for "black power." The early non-violent approach by Dr. Martin Luther King exerted influence only over a small handful of young American-born Chinese who led a fight against discrimination, social injustice and poverty in and out of Chinatown. Unfortunately, for the majority of Chinese, this type of community action was at best alien and, at worst, suspicious, an unrespectable threat to the disguised social tranquillity and hard-won status quo in Chinatown. Aside from bringing the Economic Opportunity Council (EOC)—a federal anti-poverty program—into Chinatown and achieving token success in their fight against poverty and exploitation, the small handful of young activists and missionary-minded liberals made no significant impact on the politically unsophisticated and socially indifferent Chinese community. In fact, they quickly became "enemies" in the eyes of the Chinatown establishment, and—very much like the civil rights workers led by Dr. King—ended their efforts in total frustration and helplessness. Thus the way was paved for another alternative: a more militant approach to social reform.

But before we take up the new militancy in Chinatown, we must look into yet another factor that further aggravated Chinatown problems: the new influx of immigrants from Hong Kong. From June 4, 1962, to the end of 1965, President John F. Kennedy, invoking the provisions of existing legislation, permitted over 15,000 Chinese refugees to enter the U. S. as parolees in response to the puzzling massive exodus of Chinese refugees to Hong Kong in May 1962. Immediately thereafter, on October 3, 1965, the discriminatory and anti-Chinese immigration quota system was abolished, and thousands of Chinese came over to rejoin their long-separated families. About 25,000 Chinese immigrants entered the U. S. each year, many of them settling in San Francisco.* The Federal government did nothing to assist these Chinese new arrivals, in contrast to its massive aid to the Hungarian, Cuban and Czechoslovakian immigrants. Instead of considering these immigrants as potential benefit to the United States, the government and some selfish and self-righteous Chinese took them as a burden to San Francisco and themselves. Due to ignorance, petty politics, rigidity, defunct leadership, fractionalism and limited resources, the Chinese community offered little significant help. As a result, problems in Chinatown were greatly intensified after 1962. Worse yet, the so-called Chinatown leadership, under mounting criticism and pressure from labor unions (since summer 1967) and young Chinese activists, became more conservative and reactionary. It persistently denied the existence of any social and economic problems and insisted that Chinatown could always take care of its own problems—a claim that had some validity during the pre-war days. This blunt refusal to assume responsibility for helping the immigrants clearly revealed how far removed the Chinese Six Companies and its affiliated associations had become from their original goals of service.

So the situation continued to deteriorate while Chinatown leadership, EOC, schools and government agencies continued to act as if there were no problems at all. Chinese people obviously were expected to endure the most severe hardship and

*This figure included the new arrivals and those who changed their status under various programs, such as "parolees," "confession," etc.

96

degradation without uttering a word of complaint. People in power took advantage of the fact that the Chinese would not resort to the kinds of rioting and violence which were then witnessed in all major cities across the nation.

3. WHAT HAPPENED IN 1968?

From all indications there was no chance for anyone to see the affliction of our people and to hear our cry for help. It was, however, precisely at this moment that George Woo, a foreign-born ex-photographer, emerged with clank and clamor. His appearance signaled the beginning of a new era in Chinatown.

The time was right; the stage was set. Ironically, the stage was the little-used auditorium of the conservative Chinese-American Citizens Alliance (CACA) on the evening of February 28, 1968. The occasion was a public meeting sponsored by the Chinatown-North Beach Advisory Council of the Human Rights Commission for the purpose of discussing the problems of youth in Chinatown. These problems had come to the fore for the first time in the early 1950's when the community was suddenly confronted by several hundred China-born teenagers who had entered the U. S. at San Francisco as the citizen children of Chinese-Americans. A cross-section of the Chinese community was present to discuss the situation; so were the mass media. With a battery of vituperations never before heard in Chinatown, George Woo, acting as a spokesman for Wah Ching, a foreign-born youth group, dragged out mercilessly all the dirty laundry in public. Relentlessly attacking the Chinese establishment, George Woo demanded vehemently that something be done for Chinatown youth immediately before the situation "turned into a riot." The new confrontation technique and verbal bluntness—a tactic

then commonly used by militant blacks throughout the nation—shocked the normally sedate and staid community and caught the Chinatown establishment and white society by surprise. As expected, the Chinatown establishment took it to be a tremendous loss of face and disgrace. The silent majority probably agreed that problems did exist, but certainly objected to the manner and language used to voice these problems. For the earlier activists, however, the occasion merely re-affirmed in a more forceful and dramatic manner what they had been trying to say a few years before.

All in all, it was a historical evening for Chinatown. It set the tone and pace for a number of public meetings in the following years. More significant was the way the "confrontation tactic" so polarized the community. On the one hand, there were the face-conscious, traditional, family-oriented people who guarded the status-quo with fervor and preferred to live in a world free of problems. On this same side belonged also many of the school teachers and administrators who remained unaware of or uninvolved in the problems and life of the community. On the other hand, there were the few who were progressive, reform-minded, but too anxious to bring traditional Chinatown into the mainstream of twentieth century American life. Again, the conflict reflected the deep-seated differences in generations, culture and education. The conflict is still very much alive and will continue for years to come.

But even though the evening made mentionable the unmentionable and created considerable discussion in some circles, there was neither competent leadership nor an established mechanism available to effect necessary changes. Resources of existing service agencies were fragmented and inadequate; associations and business organizations were unwilling and even powerless to do anything. Needless to say, the government, in collaboration with the Chinatown establishment, was used to doing nothing for the Chinese "who always take care of their own problems."

By late spring, it was clear that any reform or change must ultimately come from the young people themselves. But the young people had to be organized to concentrate their energy and anger on community problems.

When I assumed the office of the director of the Summer Youth Program (SYP) in May 1968, my goal was to do what I could, within my limited experience and resources, to bring about some community-wide reform program for the youth with the help of young people and to develop new young leaders in Chinatown. Development of summer jobs, educational and recreational programs and facilities were our immediate goals. More important, however, was to utilize all our available resources to develop a year-round youth program and set up a permanent mechanism for social change. To realize these two long-term goals, youth in Chinatown had to be organized and united. The community had to be constantly educated on community problems by words and actions: a newspaper, information booklets, pamphlets, community-wide cultural and recreational events, street fairs, service projects, etc. Chinese college students in the Bay Area had to return to community life and affairs; and in every aspect of community life, young people had to assert their presence and play a critical and constructive role.

Important in this process was the involvement of Chinese college students from the San Francisco Bay Area. Without doubt, one of the tragedies of the Chinese in the U. S. is the fact that those who have achieved moderate educational and economic success in the white society have preferred to believe in the myth of assimilation and to forget about the majority of Chinese who never have the opportunity to do the same. During the post-war

period, Chinatown witnessed a continuous exodus of its best resources and leaders, leaving the non-English speaking, educationally and economically deprived mass behind. Most Chinese college students belong to this latter group. Fortunately, in the spring and summer of 1968, the trend began to move slightly in the opposite direction. The new trend, started by a small number of students, represented a change in attitude about the Chinese community and a willingness to commit oneself entirely to the community and its people. Partly influenced by the militant black movements, but mostly because of the lack of identity, many Chinese college students began to apply the meaning of white racism to the historical experience of the Chinese in the U. S. and the social and economic life of Chinatown. It did not take long for these students to adopt the goals and tactics of black movements, even though in most cases they were not applicable to the Chinese community. They returned to Chinatown to identify themselves with the struggling Chinese minority. Unlike the earlier college students' involvement which was limited to "missionary" type projects such as tutoring, interpreting and occasional picnics and parties for children in Chinatown, the new breed of college students became a part of the community. Whether it be sweeping the streets, carrying lumber, teaching the ABC's, interpreting, making social surveys door-to-door, attending community meetings, designing and manning a street fair, demonstrating against social injustice, draft counseling, or taking trips with young people from Chinatown, they did it, not as "outside do-gooders," but as members of the Chinese community. Students' active and vocal involvement in public meetings was especially effective. A series of "Chinatown Open Forums" initiated by the SYP 1968 and co-sponsored by various college students groups brought the prob-

lems of Chinatown out in public for public discussion. These and many other confrontations were typical of the type of student involvement in Chinatown in 1968.

Besides college students, a small group of young professional men and women also became interested in returning to Chinatown to become part of it. These professionals decided to form a coalition, Concerned Chinese for Action and Change (CCAC), with college students to effect change in Chinatown. Led by young attorney Gordon Lau, CCAC activities included protests against the demolition of the International Hotel and historic Kong Chow Temple, picketing of the Board of Education and submitting a list of twelve demands for relevant education, defending the Chinese Playground against profiteers who wanted to build a garage there, and active participation in many public meetings. Currently the CCAC is fighting for the welfare of some three thousand lady garment workers who have been victims of a long struggle between the ILGWU and the "sweatshop" owners. Outside of Chinatown, CCAC helped bring the Chinese people into active participation in the city government.

The voice of the Chinese community was no longer an exclusive right of a few individuals who never represented the community: the voice of our our elderly and youth was being heard loud and clear. More people were consulted on programs affecting Chinatown. These were some indications of changes taking place rapidly in Chinatown.

4. THE QUEST FOR ETHNIC IDENTITY

If the year 1968 was the year of rapid changes under the influence of black movements, 1969 has been the beginning of a long quest for the Chinese identity. The calculated confrontation tactic continued to be used in 1969, but its effectiveness began to wear out, as people became

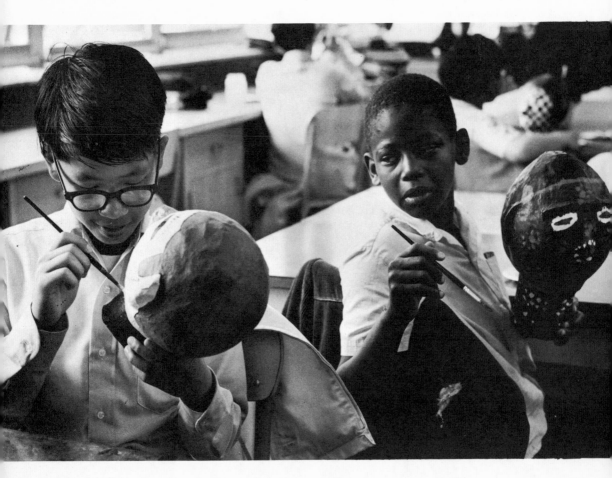

more frustrated and impatient with the pace of change. Since it was a borrowed tactic, the extent of its use was dictated for the most part by its originators, the blacks. As the tactic became progressively violent, there was little the borrowers could do to prevent the escalation of violence. The borrowers alienated themselves from their community when they blindly adopted an ideology and tactic alien to their own people.

The fight for justice and equality in and out of Chinatown in 1968 was reformist, following basically the goals of civil rights leaders such as King, Wilkins, Young, and Farmer. The tactic was essentially non-violent, although in keeping with prevailing national trends, verbal abuses and threats of violence occurred frequently along with occasional minor disruption of meetings. There was obviously a need to borrow these goals and tactics of the blacks to fight against discrimination and indifference. But in doing so, the Chinese youth displayed their lack of identity: instead of formulating their goals and tactics, they adopted everything from the blacks or whites. For the most part, what they borrowed seemed applicable to Chinatown, but by Fall 1968, these young people — as black students did too — became increasingly impatient with the pace of change. Under the leadership of the so-called "black revolutionaries" in San Francisco State College, a number of the Asian students who had been active in Chinatown (ICSA) joined forces with the blacks and Chicanos to form the Third World Liberation Front (TWLF) and became actively involved in one of the longest and most violent student strikes in the U. S. Black rhetoric and slogans, formulated strictly for black people, were as quickly adopted by Asians as black tactics. A similar strike took place subsequently in UC Berkeley in the beginning months of 1969. Ultimately, the coalition with blacks and the demand for "Asian Studies" were reflective again of Asian-Americans' need to adopt black goals and black tactics in order to find their identity, even if there was nothing in common between the Asians and the blacks.

Thus far this year there has been a gradual radicalization of the young Chinese-Americans through merging with other ethnic groups or movements, and an increasing alienation from the Chinese community. Some joined the black struggle by adopting black demands and tactics — for example, the Red Guards in Chinatown. Other Asians, in their search for identity, joined the white radical movements — SDS, Progressive Labor, or the Women's Liberation Front. Many tried to combine a little of everything. In all cases, there was an increasing alienation from Asian communities and an obvious lack of identity and ideology. Unlike community-based black movements, Asian movements have yet to move their bases of operation from university settings to Asian communities. University programs in Asian Studies seem at the present time to offer the best opportunity for Chinese students to relate their education to community problems.

5. PROSPECTS FOR THE FUTURE

Chinatown is in transition. The problems described in this essay demand immediate solution. Our people must have their basic educational, economic and social rights as citizens of the U. S. No one should be allowed to obstruct solution to these basic problems of livelihood in Chinatown. Regardless of our ideology, or lack of it, our immediate goal is justice and equality for our people. Our greatest enemies are still racism and facism in all forms and fractionalism among ourselves.

Beyond our immediate tasks we must acquire an understanding of ourselves. Knowledge of our

history and culture will enhance the understanding
of our destiny as a people. But ideology must be
formulated in light of the reality of America. We
have gone past the stages in which we uncritically
adopted black or white goals, rhetoric and tactics.
Even though we learned much from black leader-
ship, and we undoubtedly will continue to learn
from it, we must stop denying our real self, as a
people with a destiny of our own. Equally self-
destructive is the blind faith in the myth of assimi-
lation and blanket acceptance of white values. In
both instances we deceive and betray ourselves and
and our people and deny ourselves the possibility
of definite identity and self-determination. We
have a long history and a rich culture. We want
to build a new community that is truly ours, not
the one that caters only to tourism. As a minor-
ity group in the U. S. and a decisive majority
race in the world, our people have a unique and
important role in the history of this country
and the destiny of the human race. ☰

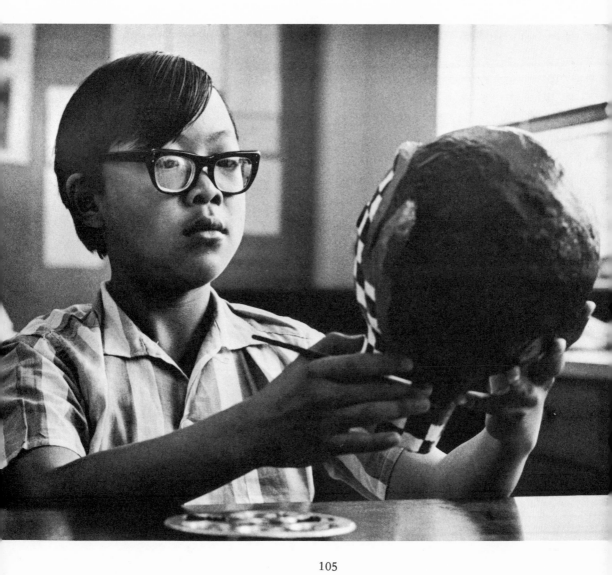

Seeking the MIDDLE KINGDOM is like finding the true dream within.

The Sage tells of a fish from the ocean and a bird of the air. The fish and the bird became friends. They told of the beautiful things in each others' domain, so that each expressed a desire to see the other's home. But the fish had great difficulty out of his natural environment and the bird likewise could not make entry into the waters. Having failed, they began to foster doubts over each other's stories. While involved in such foolishness a whale came along and swallowed both fish and bird — along with their doubts. Now, both the fish and the bird's stories are true but their doubts robbed them of their lives. The air and the water supported both fish and bird, but only the fish can live in the water and the bird only in the air.

Seeking the change which is too abrupt is stepping out of the natural. The fish cannot see what is above nor the bird what is below. When we do not adjust our perceptions to what is above or what is below, then our visions are susceptible to the confusion of both. The real is the awareness and the unreal, the distortions obstructing its clarity. Clarity of vision is the strength of the MIDDLE KINGDOM.

—*J. Feisheng Wong*
"The Middle Kingdom"

Contributors

CHOY KAM-MAN acquired the title of Master in Tai Chi Chuan through the tutelage of his father, Master Choy Hok-pang, and has been teaching in the San Francisco Bay Area since 1960. Today he gives classes in Berkeley and the Chinese YMCA in San Francisco to almost one hundred students of all ages and racial backgrounds. Master Choy is planning a book on Tai Chi with the collaboration of one of his closer students, San Francisco playwright Michael McClure.

WILLIAM T. R. CHUNG, formerly a diplomat, author, and soldier with the Nationalist Chinese government, has taught courses in the *Tao Te Ching* and *I Ching* at the California Institute of Asian Studies in San Francisco. Now he is the Director of the Chinese Culture Center in Berkeley, where he maintains classes in Chinese language, calligraphy, and Tai Chi Chuan.

LONI DING has come from teaching social psychology at the university level to become a programmer/organizer for the San Francisco Art Commission Neighborhood Arts Program, assigned to the Chinatown-North Beach community. The program has done excellent work in seeking out and helping to present good art which is alive and meaningful to the various ethnic communities of San Francisco.

MADELEINE FU (*neé* Chu Hsia) is a native of Peking. She has studied painting under the masters Fu Tieh-nien and Chang Ta-ts'ien, and now maintains her own classes at Fu's Art Studio in Mill Valley and the Chinese YWCA in San Francisco.

PAUL PEI-JEN HAU has studied Chinese painting, poetry, and calligraphy under the masters Huang Pin-hung and Cheng Shi-chu. His one-man shows have been as widely separated as Peking and San Francisco. Mr. Hau now lectures in Chinese Painting at the California Institute of Asian Studies, San Francisco.

KAI-YU HSU is Professor of Humanities, World Literature, and Foreign Languages at San Francisco State College. He is an illuminating student and critic of the vast stretch of twentieth century Chinese intellectual history so little known in this country.

KEM LEE (Lee Sui-yum) immigrated to San Francisco at the age of fifteen, to become one of the most prolific photographers of San Francisco Chinatown in the years since 1920. He has contributed to both Chinese and English newspapers, magazines, and books from Hong Kong to New York. In addition to his studio work, he has recently assumed management of the Golden Pacific, an El Cerrito restaurant and exhibit center for Chinese culture.

RUBY LEE, an extremely versatile young artist who arrived in this country only a few years ago, is already a scholarship student in the field of commercial art. Her design was chosen for the official Chinese New Year Street Fair poster in 1969, the "Year of the Rooster."

LORNA LOGAN, Director of Social Work at the Donaldina Cameron House, has lived and worked in San Francisco Chinatown since 1932. Like Miss

Cameron herself, with whom she had the privilege of working in those earlier years, Miss Logan has helped many Chinese since then bridge the difficulties of crossing from China to the U.S.

CHIN-SAN LONG, APSA, FRPS, EFIAP, is the current President of the Photographic Society of China. His photographs have received more than eighty awards from many different countries of the world. Though his children are all in California, Mr. Long is a world traveler who has made San Francisco his second home.

IRENE POON holds an M.A. in Photography from San Francisco State College, and has studied under Jack Welpott and Don Worth. One-woman shows of her work have been given in San Francisco, Sacramento, and Davis. She is now working for S. F. State while getting together a book of her work.

KENNETH REXROTH is well-known for his translations of classical Chinese and Japanese poetry as well as many other volumes of his own poetry and translations from Spanish, Greek, and French.

GARY SNYDER is a San Francisco poet whose work draws timelessness, humor, and relevance from long-time study and practice of Buddhism, in Japan and in association with the Zen Centers in San Francisco and Tassajara, California. He has given his time freely to West Coast poetry readings and other events in support of peace and ecological sanity.

LILY TOM has taken her M.A. in Sociology and pursued independent studies in art and Oriental culture under such teachers as the Japanese *sumiye* and woodcut master Un-itsi Hiratsuka. A devotee of Chinese swordswoman movies, she has recently taken up classes in Kung Fu from a San Francisco master.

TSENG TA-YU, poet, artist, and critic, lectures in Chinese art, language, and calligraphy at the California Institute of Asian Studies and the College of the Holy Names. A close student of both Western and Eastern art and literature, he has given much of his time and energy to lectures, readings, and other presentations introducing East and West to each other's culture. His collection of classical Chinese poems, accompanied by translations and commentary, is awaiting publication in London.

L. LING-CHI WANG came to the U.S. from Amoy, Fukien, to study Theology and Ancient Near Eastern Languages. Now a Regents' Fellow and Ph.D. candidate at the University of California, Mr. Wang divides his time between academic work and extensive involvement in Chinese community affairs. His experimental courses in Asian Studies at the University have combined academic research with direct community involvement.

J. FEISHENG WONG, artist and poet, is a student of Eastern and Western schools of mysticism and metaphysics, currently employed at the Metaphysical Town Hall Bookshop in San Francisco.

LUI-SANG WONG is a disciple of Chao Shao-an, the contemporary master of *Lin Nan P'ai,* the school of modern Chinese art which seeks to make traditional techniques more contemporary through an alliance with the best points of Western art. He has given numerous one-man shows in China, Japan, Canada, and the U. S. Mr. Wong is the Director of the East Wind Art Studio in San Francisco, where he gives instruction in Chinese painting and calligraphy to students of all ages and backgrounds.

NANYING STELLA WONG, artist, novelist, and poet, spearheaded the Committee to Save the Kong Chow Temple, oldest Chinese temple in the U. S., finally destroyed by S. F. business interests in March, 1969. She is the great-niece of Yee Oi-Tai, mentioned in her free-verse presentation of this story. Her paintings, which have been exhibited throughout California, are now on view at the Golden Pacific restaurant and culture center in El Cerrito.

VICTOR WONG is a cameraman and photographer for KQED Newsroom in San Francisco, and a sympathetic interpreter of all Bay Area ethnic community movements and their developing search for identity and equality. He has contributed in many different ways to recent media attempts to re-discover and present the history and contributions of the Chinese people in California.

Acknowledgments

Ting: The Caldron *is grateful to:*

STELLA LEE for the Chinese on pp. 60-66.

CHRISTA FLEISCHMANN, who photographed most of the art.

HENRY NOYES, owner of China Books, San Francisco, for permission to use the illustration and vignettes by Chi Pa-shih (pp. 11, 28, 109).

PETER BAILEY of East Wind Printers for his patient help with production.

ROGER LEVENSON at the Tamalpais Press, Berkeley, for supplying the display proofs.

New Directions Publishing Corporation, for generous permission to include Kenneth Rexroth's translation of Tu Fu on p. 26. (Kenneth Rexroth, *One Hundred Poems from the Chinese.* All Rights Reserved)

Mercury Enterprises for permission to print the still from *Thirteenth Sister* which appears on p. 80.

"Cold Mountain Poems" were originally published in *Evergreen Review,* Vol. 2, No. 6, and are used here with the author's permission. ©1958 by Gary Snyder.

"Modern Chinese Poetry" and the translations which accompany it were originally published in *Twentieth Century Chinese Poetry: An Anthology* by Kai-yu Hsu, and appear with the author's permission.

More generally, *Ting* is indebted to the following persons for its whole development and direction:

ELIZABETH ABBOTT
Then *Director, Clay Street Center* YWCA

ALICE LEUNG BARKLEY
Program Coordinator, Community Design Center
University of California Extension

BERNICE BING
Programmer/Organizer, S.F. Art Commission
Neighborhood Arts Program

ROSEMARY CHAN
Community Screening Teacher, S.F.

ST. MARY'S COLLEGE OF MARYLAND
ST. MARY'S CITY, MARYLAND

PEGGY DIGGS

Artist and teacher

DATE DUE

Many other persons who expressed their willingness and desire to help were finally limited by the demands of present duties. Their encouragement alone was a valuable contribution.

Finally the editor would like to thank his family and the Glide Communications staff, Donald Kuhn and Ruth Gottstein, for their patient editorial assistance and support throughout this work.